CHARLES SHEELER

Artist in the American Tradition

Library of American Art

CHARLES SHEELER

Artist in the American Tradition

By Constance Rourke

Kennedy Galleries, Inc. · Da Capo Press
New York · 1969

CHARLES SHEELER

Artist in the American Tradition

CHARLES SHEELER

Artist in the American Tradition

BY CONSTANCE ROURKE

WITH 48 HALFTONES OF PAINTINGS, DRAWINGS,

AND PHOTOGRAPHS BY CHARLES SHEELER

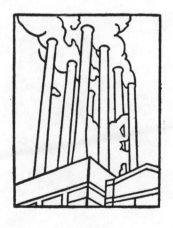

Harcourt, Brace and Company New York

Typography by Robert Josephy

PRINTED IN THE UNITED STATES OF AMERICA

Note

SOME years ago a number of wholesome inquiries were begun as to the position of the American artist. Their view tended to be retrospective, their conclusions were disheartening. Charges were made against our civilization of the past: it had failed to produce a culture in which the arts could flourish or an audience that was responsive, and in consequence—so the argument ran—the artist had frequently been driven abroad, or if he remained at home he had led a thwarted existence. These ideas fell in with another, much older, strain of thought, that all our art was necessarily an offshoot of European art, and this group of rather powerful opinions made a climate in which many artists of the present day have come to maturity, perhaps not the whole climate, but at least a strong bit of blowing weather.

What one occasionally felt about these discussions was that they pushed the matter too far, and that they failed to take heed of creative forces which have existed among us, particularly in the past. Possibly our soil has not been too shallow for a full creative expression. Perhaps traditions were being slowly created in our formative years which may be richly employed by the contemporary worker in the arts.

Thus a special interest attaches to the career of an artist of distinguished achievement whose lineage in art is unmistakably our own. The work of Charles Sheeler has been noticed for its fresh and original use of the American subject; and still further for the imprint it shows of forms which strongly and essentially belong to us. The influences under which this art was evolved, the choices which the artist has made, may reveal some of our fundamental traditions and resources. They

5

will not fully explain the character of Sheeler's art or his stature as an artist: these broader implications are set within a purely individual story, but this too may have something to say as to the questions with which we have been so persistently concerned.

This informal biography has drawn freely upon Charles Sheeler's notes—what he calls a "case history"—and upon conversations with the artist. In the choice of reproductions of paintings and drawings interwoven with the narrative, an effort has been made to show the development of his art from its early and more experimental stages to those of its maturity. Main outlines have been considered of greater importance than precise references to every picture. Since Sheeler's photography has been a major occupation and interest, its development has become part of the essential story, and is illustrated by a group of examples selected because of their typical conquests in this field. Perhaps Sheeler stands alone in having achieved distinction in both painting and photography.

Grateful acknowledgment is offered to Edith Gregor Halpert, Director of the Downtown Gallery, for the many courtesies which she has extended during the evolution of this book. Appreciation is also offered the owners of Sheeler's works who have generously permitted their reproduction. William Carlos Williams, Edward J. Steichen, Robert Allerton Parker, Matthew Josephson, have inevitably become *dramatis personae* because of their long friendship with the artist, and they have helped to make the writing of the book an enlivening affair: but—to utter the familiar warning—they must not be held responsible for its interpretations. Quite possibly they, or even the main protagonist, may not agree with its ideas or judgments.

PAINTINGS, DRAWINGS, AND PHOTOGRAPHS
BY CHARLES SHEELER

7

Illustrations

8

Illustrations

9

CHARLES SHEELER

Artist in the American Tradition

1

CHARLES SHEELER was born in Philadelphia in 1883 of a family long rooted in eastern Pennsylvania whose descent was Welsh and Irish. Neither of his parents had been concerned with the arts; their approval of his determination to be a painter derived from warm mutual understanding. "My beginnings were auspicious in that my family had faith in my choice, and that I did not believe myself to be a voice crying in the wilderness. My motive was a purely personal one. I wanted to paint more than anything else."

What presented itself was not so much a wilderness as a waste, with no guide or compass, when his high school term was finished. The unstable position of the artist as bread-winner was stressed by the Director of the Academy of Fine Arts in Philadelphia to whom he went for advice. This gentleman had no doubt been consulted by many young people looking with longing eyes toward the arts; a wistful desire for the embellishments of life seemed to be driving numbers of them toward the art schools, apparently with the further intention of placing themselves outside commerce, a drifting group who now are as likely to take correspondence courses in journalism or the technique of the short story. Sheeler felt that the director was deliberately trying to be discouraging, but he accepted the advice offered him, and

entered, not the Academy, but the School of Industrial Art for a three-year course; at the end of that time he would supposedly have acquired a means of self-support, and he could then decide whether he wished to enter the great world of the fine arts. The cleavage between the two seemed to be complete. The fine arts were luxury, the practical arts were drudgery. "The fine arts," Sheeler thought, "were something sacred, aloof."

The old phrase "applied art" fitted the pedagogy of the school precisely. The emphasis was invariably two-dimensional. "Forms in the round were considered outside our province, and we had nothing to do with things that were used or handled. The idea of function or use never entered into our heads." Patterns were created for application to flat surfaces such as carpets and wallpapers—designs deriving from the Greek, Egyptian, Romanesque, and Gothic, whose forms were assiduously studied, copied, and adapted. Greek forms were considered the safest and most essential, so drawing from casts of Greek sculpture was included in the course, with a study of the various orders of architectural ornament. The idea was to teach young people to shuffle these forms in slightly new arrangements.

To add a touch of glamor to an arid business a life class and a class in watercolor were included in the course, and it was to these that young Sheeler, rushing through the required work, devoted himself.

"One day a stocky little man, gray-haired and gray-bearded, passed through our workroom. His trousers were tucked into short leather boots and fitted so snugly as to make the braces over his dark sweater

superfluous. Neither his appearance nor his manner offered a clew as to the reason for his visit. A few days later he returned and passed to the life-class room, just beyond where we were working. Knotholes in the board partition were used at intervals and permitted us to satisfy our curiosity. The stocky little man was beginning a portrait of the principal of the school, Leslie Miller, and before long the plan of the picture was indicated. The subject was to be portrayed standing easily with one hand in his trouser pocket and the other holding a manuscript from which he raised his eyes as if to direct them toward an audience. As the artist's work continued we witnessed the progress of a perspective drawing which was made on paper and then transferred to the canvas, to account for charts of ornament receding into the background—those charts which we knew only too well. This careful procedure led us to the conclusion that the man, whoever he was, couldn't be a great artist, for we had learned somewhere that great artists painted only by inspiration, a process akin to magic.

"Several months were thus consumed; then came a day, as we discovered through the convenient knotholes, when another perspective drawing was made and transferred to the canvas, on the floor and to one side. The letters spelled Eakins. The name was not familiar to us."

Eakins had partially emerged from the solitude into which he had retired after his warfare at the Academy over models in the nude. This had long since died down, nude models were now employed everywhere; but Eakins never resumed association with active movements in contemporary art. He had had ardently admiring pupils and had

kept some of them, yet even so he remained apart, and is still an isolated figure in our art history, having produced no notable descendants, having brought about no positive new impetus. Sheeler never saw him again.

One of the instructors in the school, Herman Diegendesch, offered the use of his studio on Saturdays, where Sheeler could work in oil more or less under direction, finding subjects for himself in a bit of still life or a corner of the room itself. Horizons were widened as Diegendesch, quiet, friendly, discussed artists whom he had known in Munich, and still further by his patient explanation of the varied ways in which different painters would have handled the immediate subject at hand. This was a new idea; art had been, well, just art—one hit it off somehow, plunged into it. Sheeler worked furiously, "full of the itch to paint, impatient of the days that kept the Saturdays apart." Diegendesch also taught him etching. When the course at the school was ended, industrialism was to be left behind: that much was sure; the question was how to make the best entry into the exalted world of the fine arts. Diegendesch argued for the advantages of Munich, but Munich was too expensive. In the end Sheeler enrolled at the Pennsylvania Academy as a student under William M. Chase.

What may be called the genius school of art and literature was still in the strong ascendant—if it has ever died—and Chase did much to prolong the idea among young artists and among buyers of art. The artist, he tacitly proclaimed, was different from the common man, yet not too different. With his impeccable clothes cut just this side Bohemianism, his famous high flat-brimmed hat, his pointed beard, black

eyeglass ribbon, and the perennial white carnation, Chase was the showman, displaying art as gay, bright, and only a little mysterious. Born in Indiana in the first year of the California gold rush, he seemed to carry with him the glitter of that era throughout a fairly charmed life. Nothing of the salt or savor of his native region appears in his work; even his stay in the Mississippi Valley, after his first apprenticeship as an artist in New York, produced no effect of native alliances. He had come back from his study in Munich like a brimming beaker, his natural exuberance heightened by the consciousness that art could offer a lively, conspicuous vocation. His philosophy was simple. It was illusionist—that is to say, sophisticated, but not bitter. The idea was to catch the fleeting moment. He said, in effect, and indeed one could easily prove it, that the moment was all that could be caught. This philosophy sprang from impressionism or the other way around, but impressionism in this country had become extremely delicate; this art seemed fairly robust and positive; it spoke to that famous entity who has always haunted the arts, the man in the street, who could understand black capes, handsome silks, fine furniture, brass tea kettles, and who also quickly learned to see the marvels of technique: "See that hand—done with only a couple of brush-strokes!"

In many ways the drift was characteristically our own: it was sheer theatre. A sense of theatre has always belonged to the American character, whatever may be said to the contrary by those intent upon proving our repressions. It has developed in many forms offstage, in common speech, in oratory, in all the arts. Sometimes it has deepened into drama or poetry or prophecy; it has a genuine place in the touch

and go of everyday life, making for lively surfaces. In art, surfaces obviously have a complete importance. They form indeed the final medium in the plastic arts; only through their illusory forms may body, structure, significance be revealed. But dazzle and shimmer for their own sake, as Chase displayed these, are another matter. Undoubtedly, Chase put up something of a fight for art but it was the wrong kind of fight. He was powerful because he fell in with an era when timidity was mingled with large-scale display, and he matched the display. The fish and the onions of his still lifes were supposed to be humble subjects but he made them spectacular. His showy portraits, his easy landscapes comprised an art whose main appeal was that of luxury.

Chase was now teaching and painting in both Philadelphia and New York. His studios, adorned by spoils from many lands, were public highways traversed by a horde of pupils and sitters; probably no American teacher ever had so many pupils. To the dozens of young men and women who came within his radius all this activity was immensely stirring. He would stop at a student's easel and swiftly paint his picture for him, thus proving that art was not so difficult after all, that it might be easy and companionable. "Don't touch it," he would cry as he looked at a sketch which he could praise. Spontaneity was his watchword. Studies must be completed at a single sitting. Within this loose pattern of spontaneity, technique became primary rather than the soberer matter of craftsmanship.

"The long quivering brush-stroke was what we were after. Nature was a peg on which to hang the garment of manual dexterity. The

18

statement was of little or no importance—the word never entered our vocabulary. The mechanics of painting was what mattered—brilliance, fluency.

"But how exciting this all was! What a waste of time, the hours required for sleep when one could be painting round the clock! The excitement caused by the gleam of light on brass or copper was in our blood, and we spent feverish, impatient hours trying to set it down on canvas."

In his rapid talks Chase would describe some of the great European paintings, with emphasis upon Velasquez and Hals. Examples of their work were to be seen in the Widener collection, and the Pennsylvania Museum showed a few old masters in the midst of a galaxy of salon pictures; but even with occasional excursions to New York, opportunities were meager at this time for a young artist to obtain first-hand knowledge of the great European painting of the past. Photographs of the paintings of acknowledged masters were offered students as a main source of inspiration, as they still are in out-of-the-way schools and colleges—a waste of brown.

As for American painting of the older periods, no museum had learned that this might have something to say to the young American artist. At the Academy, an ancient rambling piece of architecture modeled after the buildings in the Zoological Gardens, a scattering of American portraits of varying styles and significance hung unnoticed along the staircases and in the halls, with other American works relegated to dark corners of the basement or attic.

So Chase's running conversation about painting in the galleries of

Europe created its own excitement, and when he proposed to take a number of the class abroad in the summer for study this was a genuine novelty in teaching procedure.

Sheeler made the trip as a solitary passenger on a cattleboat, economically, joining the others in London. Mornings were devoted to independent exploration of the galleries, afternoons to painting in the class under Chase, with digressions as he obtained invitations for its members to visit some of his famous friends: Alma-Tadema, Leighton, Lavery, Brangwyn, Shannon, Abbey, and Sargent—the great contemporary English-speaking masters. They visited the lavish old Roman villa of Alma-Tadema with its polished brass stairs and gardens. Leighton's classic dwelling told the same story; the classic revival was in fact having another day in England at this time. A rosy future was promised by the almost invariably distinguished appearance of the artists, in their black velvet sack coats, and their flowing cerulean or crimson ties. Plenty of people had told these young men that art was precarious: here was the refutation in these handsome houses and authoritative costumes, though misgivings struck some of them as they surveyed the immense pallid paintings on the walls.

Their spirits rose, momentarily at least, when they visited Sargent's studio because as an American he brought the glittering promise nearer home. The picture on Sargent's easel was the portrait of Miss Wertheimer, with a black cape imperiously thrown back over one shoulder. Chase ecstatically told Sargent that it would be necessary to go back to Hals for the equal of the blacks. Chase and Sargent faced each other—"Chase was short and bristling, Sargent tall, hefty, modest in

outward demeanor. One had to be told that he was Sargent if one was to know. Later, seeing the portraits by Hals in Haarlem, and remembering the flush of red that rapidly mounted the back of Sargent's neck upon receiving the compliment about the blacks, we were convinced that his embarrassment was genuine.

"In Haarlem we also discovered a painting which may have given Chase ideas about his personal appearance, a large portrait group of officers. One of them is seated conspicuously forward, with the same pointed beard and bristling mustachios which Chase tormented in his more dramatic moments. The orange scarf across the chest was missing but the broad black ribbon of Chase's eyeglasses made a similar mark. Once as he looked at a photograph of this painting he remarked rather shyly, 'They tell me I look quite a bit like that fellow!'

"Holland was both picturesque and strange. Picturesqueness plus strangeness equaled paintable—then the most overworked word in our vocabulary." Paintable—paintable: something ingratiating, charming. The young men would gladly have settled down in Holland to dash off portfolios of sketches but they had only three days, and they had to see Rembrandt and Ruysdael as well as Vermeer, De Hoogh, Terborch. These last particularly attracted Sheeler; he thought they were mistakenly called "little masters."

"Then there was Hals who, with all that Chase had said about him, claimed the right of way. Brilliancy to the nth degree—and those blacks! They have seldom been equaled and never surpassed.

"The days were packed with concentrated nourishment, some of which was to be assimilated later on. We went home at concert pitch,

determined to outdo Hals and possibly to improve upon him. I do not recall that this was ever accomplished.

"It was still the order of the day to strive for the completion of a painting at a single sitting. This was right, for we didn't have the eyes to see beyond what a single sitting could reveal.

"With the arrival of spring we went out into the country around Philadelphia to paint farmhouses in the midst of fields, buildings reflected in the placid water of a canal, or bits of woodland. Since our panels were small and what we required of a picture was very slight we often returned at the end of a day with quite a harvest. Now that landscape was added to our repertoire we scarcely had time for breathing. When Chase offered at the end of the year to show a few of us Velasquez, Goya, Greco, we felt the world was in our grasp. After a visit to Spain we would have everything.

"Gibraltar was an original so well known by reproduction that the first view of it, through a porthole, suggested plagiarism. At Ronda, where we stopped for the night, we were unprepared to meet those cliffs—such heights or depths, depending upon one's point of view, suggesting cruelty and finality of answer. At Cordova we stopped to see the Spain that was Moorish, then slept in the train going north on boards among some picadors, with a sense of great adventure. All this, with glimpses of hard copper-colored mountains produced a great crescendo for our arrival in Madrid. Velasquez, Goya, Greco—we plunged in, under Chase's direction.

"The crescendo was prodigious: and we settled down to copy fragments, mainly of Velasquez. Brilliancy of execution was still to the

22

fore. No emphasis was placed upon characterization in the Velasquez portraits, none at all upon the organization of the picture. Greco was interpreted as a magnificent painter. There was no suggestion that he was a magnificent draughtsman. Later we risked opening the other eye and came to see something of his full greatness.

"A visit to Toledo revealed other Greco portraits—more existent than real people—and we saw the 'Burial of Count Orgaz.' But that had to be realized some years afterward, and without a teacher.

"Brilliance of execution remained of first and last importance in Chase's teaching. Later we laboriously learned that interest in the statement should provide its own manner of expression, and that facility in painting, for its own sake, is like the cadenza imposed upon the structure of music to display the dexterity of the musician."

With the third year at the Academy formal training was ended. Young Sheeler had great natural proficiency of hand and eye; now at about twenty-five or six he had the incubus of brilliance; he was frequently mentioned as one of Chase's favorite pupils; and distinctly the attainment was practical. Whatever qualities American art had had up to this time brilliance had not been conspicuous among them, but with Chase's wide influence and Sargent's overpowering reputation it seemed to have come to stay and in fact it has stayed, with the philosophy it represents, in the work of many later artists and schools, even though techniques have changed.

With a flock of other students from Chase's classes Sheeler went to Gloucester for the summer. "We were feeling pretty high, for we had been educated. We were out for subjects—paintable still seemed to us

23

a fine word. Those boats with their wobbly shadows in the water—what better materials could be found for our newly acquired dash and fluency!" In the fall he was "convinced that at least one picture was worthy of the Academy annual." It was accepted, hung, and promptly acquired by a Philadelphia collector.

Thus with the highroad clearly open he took a studio with Morton Schamberg, also a pupil of Chase, whom he had come to know during one of the trips abroad. Spontaneity was still the watchword; subjects were painted at a single sitting, but gradually Sheeler learned to memorize his themes, particularly the landscapes, painting them on his return to the studio though still with interest in "the moment." His subjects broadened. In common with other artists of this period he painted night scenes in parks or in streets with figures passing through patches of illumination from arc lights. American art was becoming urban, with Sloan and Bellows as leaders in this tendency. At this time Sheeler also painted a number of small imaginative pictures—fantasies—dealing with the human figure and expressing emotional moods, subjects of a type which he came later to associate with literature rather than with the plastic arts.

A few pictures were sold, though not with the dizzy haste anticipated from the first Academy success. If a swift and pleasing approximation of nature was achieved that was enough—or was it? What else was there? Surely it *was* enough. That anything basic was being left out of their work did not occur, or occurred only vaguely, to these young men.

"There were areas in our pictures left unaccounted for like the

24

empty spaces in the earliest maps, but with the important difference that the map-makers were conscious of their lack of knowledge. We were not."

These comfortable certainties were ended abruptly in 1909 by a trip abroad. Schamberg went ahead, had a few weeks in Paris, and met Sheeler in Italy, where in a rapid survey of the galleries they became suddenly aware, through the work of the great Italians, of the presence of design. In Chase's teaching, design in the contemporary structural sense had had no place. "Now we began to realize that forms could be placed with consideration for their relationship to all the other forms in a picture, not merely to those adjacent. We began to understand that a picture could be assembled arbitrarily with a concern for design, and that the result could be outside time, place, or momentary considerations." Tramping through the galleries, these young men worked hard, searching through picture after picture until their eyes fairly started from their heads, finding, particularly in the simplified, poetic handling of the primitives, those elements of design they had been missing. They were attacking a basic problem, influenced no doubt by ideas in the European air because of the rise of post-impressionism, though as yet these ideas were not too well formulated. Their conclusions were serious, radical, and final with the finality of youth. "Our interest in representing the casual appearances of nature ceased."

When Sheeler went on to Paris this direction was confirmed, with an excess of bewilderment. Post-impressionism was now breaking with a full impact at the Salon d'Automne, and occasional examples of its

newer forms could be seen at dealers on the left bank. A major group of these pictures was on view at Michael Stein's where visitors were free to come and go, study this art in silence or with conversation, particularly on Saturday evenings when open house was maintained. The pictures of the wild ones—*les fauves*—thus could freely have their say.

The great reversion was now unmistakably under way toward architectonics, which had always been a major concern of French art, which has been inherent in all classic art. Form was once more resurgent. Most of Sheeler's young American contemporaries had been searching for subjects; in this art subject was often all but eliminated in the passionate search for the balance, play, action, and inter-action of form.

These pictures contained a further element which may have complicated or simplified Sheeler's approaches: it would be hard to say which. They were highly subjective. "When one looks at a work by George Braque," said Maurice Raynal, "one is tempted to close one's eyes, the better to guard one's impressions. If I dared, I should say that Braque himself seems to paint with his eyes shut." This of course was what the jeering mob contended, that these artists had painted with their eyes shut. The usual rude comment was that their pictures were so subjective, so idiosyncratic, in brief so completely and absurdly personal that none but their authors could be expected to understand their intention. But Raynal's doubt about making the statement had to do not with the mob but with Braque who, he thought, would be reluctant to admit that he was concerned with anything but form.

26

"I wouldn't dare say this since painters wish one never to forget that they are above all painters."

What Raynal had in mind was the element of revery, of introspection. Fantasy clearly belonged to these works, with inner revelation, and this meant a new conjunction of forces in art, those of the inner mind and those of stripped and structural, abstract form.

It was a good time to be in Paris, around 1909, not only because the movement was now explicit, with many variations, but because criticism was still in a formless state as to their intention. The art of Picasso, Braque, and of those who had made the groundwork, Cézanne and Seurat, could speak without too much intervention.

Sheeler didn't pretend to understand these pictures. "They made too great a chasm to be taken in a stride. But I believed that they were understood by their authors." This was a radical step; even without full understanding he had found in them organization, not disorganization. He discovered, as did others who approached this art in these years, that when he had left it he looked at both art and nature with new eyes. They offered a full and formal discipline which—though they were abstract—made even people in the street take on fresh outlines. When he went on to London and saw again the pictures with which he had become familiar in his student days, he found that they spoke a different language, and were in effect new pictures.

Upon his return home he began, as he says, "to bail out," discarding what he had learned by his earlier study. "An indelible line had been drawn between the past and the future. I had an entirely new concept of what a picture is, but several years were to elapse before

27

pictures of my own could break through that bore a new countenance and gave a little evidence of new understanding." He had become through these decisions and their consequences one of the earliest of American artists to accept the modern movement.

2

THE NEXT MOVE was practical, toward earning a living. With brilliance overboard and a new start to be made it was obvious that paintings could not be produced with sufficient rapidity for income, even if relationships with the buying public were of the smoothest. The industrial arts had receded, seeming now more sterile than ever. Photography presented itself as a possible means to an end and was particularly attractive since it appeared to be far removed from art.

"My instinct then was to keep art antiseptic, in a world by itself, isolated from everything, isolated even from life. I eventually discovered that life comes before art, and is not something one stuffs into the nooks and crannies surrounding art to keep out the draught."

Up to this time Sheeler had taken only casual snapshots with a kodak, but he now purchased a large camera, studied its uses, and found a field for himself in Philadelphia photographing newly finished houses for their architects, who wanted the prints mainly as records. The houses were often bad hybridizations, but the effort to transcribe their masses with honesty by means of the camera meant that earning a living was not after all wholly divorced from pure esthetics. This work ran parallel to his new preoccupation with structural form in painting.

CHARLES SHEELER

Art became a matter of week-ends in Bucks County. In his Academy days Sheeler had often gone sketching in the country roundabout Philadelphia, most often in this region. Here were pleasant woodlands and fat fields with the Delaware as a tranquil boundary; this was a rich country with a resistant understructure of limestone, from which its houses and barns had been largely wrought. After the first possessive warfare among the Swedes, Dutch, and English for this territory, colonization had begun under Penn, and no doubt the unobtrusive buildings gained something from Quaker ideas of simplicity. In form they were determined by the uses to which they were to be put and by the refractory character of the material, which was most often partially faced and was finely cut for quoins and sometimes for lintels. Its colors were the modulated blue and gray, buff or rust, purple-brown or yellow of the stone except when wood was used for siding or sheathing or sometimes for the main walls of a barn; this might be painted pure white or deep red. With no narrow recession of traits these buildings are provincial, severe, without ornament, distinctive yet conforming to no strongly marked style; they represent one of the still almost unnoticed phases of our native architecture.

When the business of photography settled into a stable routine Sheeler rented a small house near Doylestown to use week-ends for painting. It was nothing like a studio. Built sometime in the mid-eighteenth century, it conformed to the prevailing style of the region. Within were strong beams, simple panels, deep embrasures, a finely twisted staircase. All was clarity: the walls were of that peculiar white which only freshly burned lime seems able to create. Only a few

pieces of necessary furniture were moved in; the house remained almost empty, so here again, as in the broad landscape outside, were interesting forms in unfiltered light.

The house had its contexts, not only in similar buildings in the surrounding territory but in collections at the old Fountain Inn in Doylestown and at the Bucks County Museum, already enriched by the Mercer collection of farm tools, household utensils, Pennsylvania slipware, primitive wrought iron, cast iron firebacks and stoves, a superb collection of useful objects which had belonged to the region. In his earlier days Sheeler had frequently stopped in those rooms of the Pennsylvania Museum which house the great Barber collection of Pennsylvania German crafts, created long before the current rise of interest in such materials. Medieval in their nearer origins, the tracings, scratchings, and cuttings, or the designs in slip of the ceramics, showed patterns that seemed akin to some of those he had been seeing in Paris. Matisse, going back to primary Asiatic sources, had restated designs not widely removed from those of this homely provincial art. The connection seemed accidental; Sheeler had no idea of drawing upon any of these materials then as subjects, but they offered a constant attraction, providing a special pleasure because of the beautiful craftsmanship which they revealed. The iron was firmly wrought, the slip surely, gaily applied, the pottery jugs as plastically secure as fine pieces of sculpture. Here again were endless studies in vigorous form, achieved with a minimum of means.

These week-ends meant more than one radical change. In the years at the Academy and during the trips abroad with Chase, later at

31

Gloucester or on other sketching trips, Sheeler had been part of a group. Now he accepted comparative isolation. This was broken when Schamberg returned from Italy; a friendship was forming which was to prove perdurable: but even though Schamberg joined him frequently and was concerned with the same ideas and problems, isolation continued in a sense since they felt themselves to be two against the world.

Perhaps they were aware of this strong position and rather consciously enjoyed its privileges. In their rapid but determined scrutinies abroad they had captured a great deal, but it was inevitable, partly because they were young, that they should fasten at first upon some of the more striking and accidental elements in the art which they had seen. Post-impressionism was considered cryptic: well, they would be cryptic. "Art was something that puzzled the layman. We could see that they tripped over it, and we proposed to give them something to trip over with a vengeance. 'What is that?' someone would ask, and I would swell with not altogether modest pleasure and say, 'That is my idea of a tree.' I thought I had achieved art because the other fellow didn't get it. I was extremely tactful for a while about not getting too close to nature."

Opportunities for tripping the public were by no means abundant. Few persons saw the pictures of these early week-ends, fewer came back to look again. They created no reverberations of any sort. Both these young men were difficult to know. Now, immersed in their new ideas and bent upon a swift seizure of the true truth, they were probably less approachable than at any time of their lives. "Sheeler was a

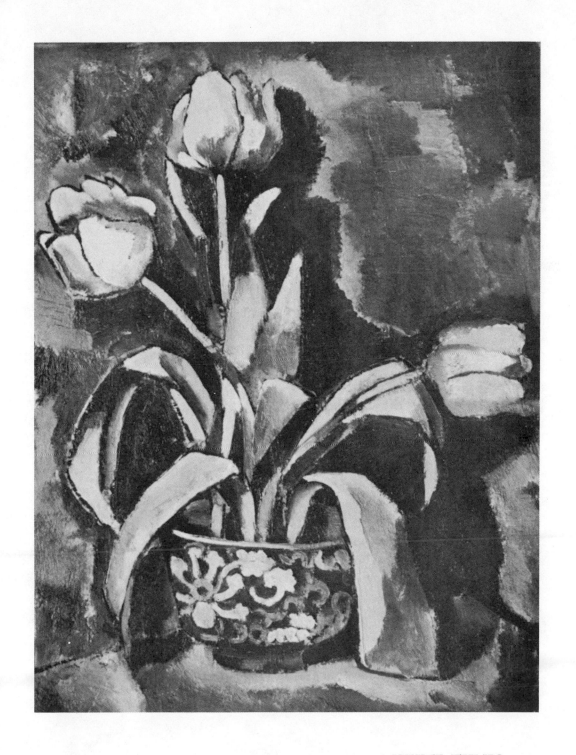

WHITE TULIPS

33

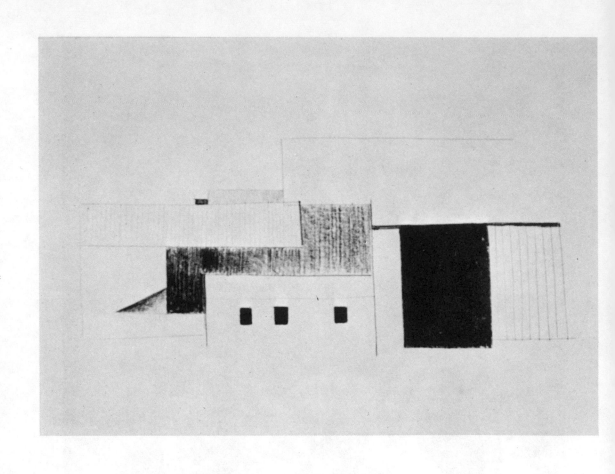

BARN ABSTRACTION

34

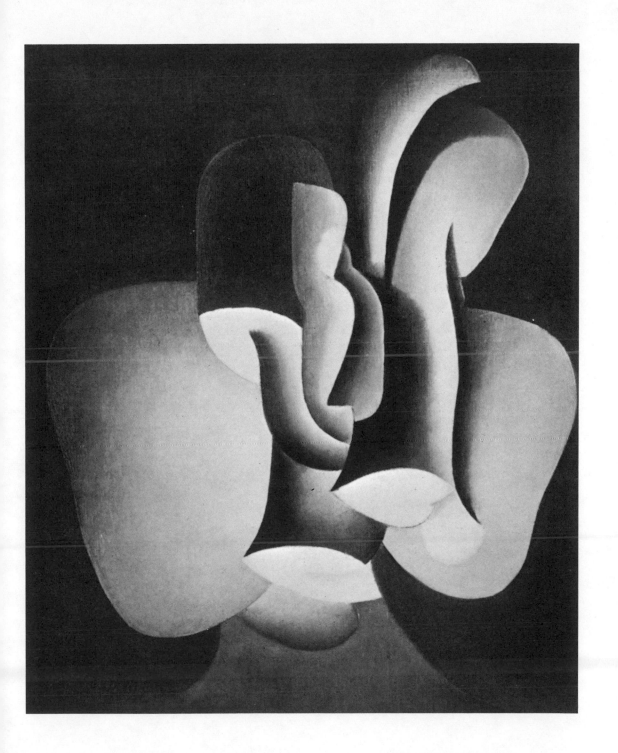

FLOWER FORMS

35

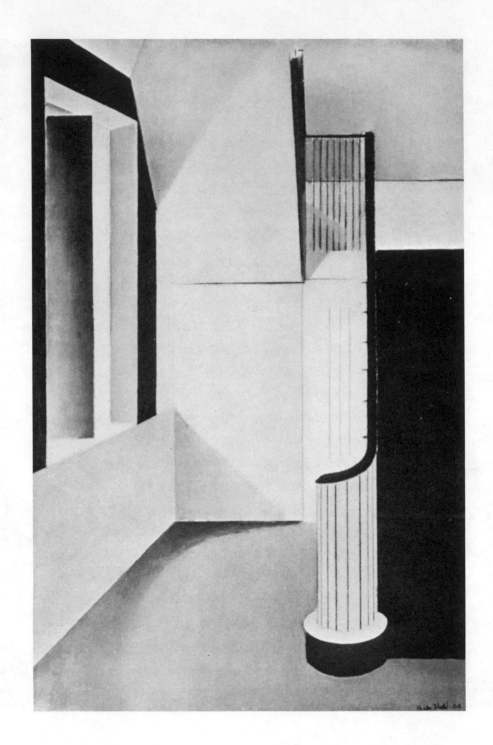

HALLWAY

36

very tall, thin, shy young man," says a contemporary, "with gray-blue eyes, very swift and silent movements. He then had a slightly impervious look, which was sensitive at the same time. One noticed his hands, which are long and large; they looked idle—they still do—but he could work with incredible rapidity. And when he let out his sense of humor it could be uproarious. It was usually dry."

"Schamberg had luster," Sheeler says, "not humor—luster belonged to his mind and to his work."

A still from an early motion picture of Sheeler's shows Schamberg partially reclining with a parroquet on his wrist, his narrow figure, the turned head and finely articulated hand against the dark. Here Sheeler did not scorn nature; the portraiture is explicit, indicating among other qualities the aloofness belonging at the time to both these young men, and their estheticism. Schamberg might have been talking theoretically about either parroquets or art. He talked constantly about pictures he was going to paint in which mechanical objects were to be a major subject, describing them in detail down to the last line and nuance of color. Many of these existed only in his mind or in conversation. He had, as it turned out, only half a dozen more years to live, but he seems to have refrained from painting in abundance less because of lowered physical vitality than from a sense of frustration.

These young artists had no one but each other to talk to about their abstruse experiments. Neither of them had the slightest idea whether their ventures belonged to this world or the next, or in any world, or what might eventuate from them. Schamberg spoke one evening at the Academy on "new movements in art" and the effort resulted in an

insinuation of madness by other speakers on the program and satirical references to a "cult" or "a mystic circle" in the press notices. Perhaps it was a minor sign of changing times that the small symposium was reported at all. The growing element in their work and in their talk was one which they shared in more than one respect. Before he had entered Chase's classes Schamberg had studied architecture at the University of Pennsylvania; Sheeler's photography of new houses was continuing. Architectonics in painting was what they were after, and it was this that they were trying to explain on the rare occasions when they could command an audience.

Sheeler soon began to build his pictures, plane by interior plane, under the influence of that monumental force, Cézanne, who had generated *les fauves*, using still lifes most often, with an occasional Bucks County house. These were greatly simplified in handling, somewhat arbitrary in color, broad in treatment, with brushwork following that of the master as this appears in the oils, with extraordinary fidelity. One of the paintings approached Cézanne closely enough to be studied in photographic reproduction with some care, as an unknown Cézanne, by an expert student who came upon it in a group of photographs of modern French paintings. But Cézanne was not the only influence. That Sheeler was following some bent of his own is shown by a painting of a brick mill above a deep waterfall, forecasting by many years his interest in the industrial subject. It is partially formalized but the character of the building is unmistakable; here are the peculiar gaunt outlines, the homely arches of brick industrial buildings of the sixties and seventies. The proportions of the canvas and the

sweep of the design suggest a source antedating Cézanne or *les fauves:* the great Toledo landscape. After all, during his brief stay in Spain, Sheeler had learned something more than rich color and fluency from Greco. The interesting thing was that, while as a rule the young artist chooses subjects similar to those of a master and often imitates compositional elements with great devotion, here we have the choice of a radically different and none too propitious theme, revealed by forms that lead the eye in arrangements of their own, moving downward where the Toledo landscape sweeps up, capturing an unmistakable rustic quality where Greco found splendor.

Color in this new work had a stained glass window quality; the dashing chiaroscuros of the Chase period were gone. Shadows were considered as concrete forms rather than as romantic interludes. The whole drive of these pictures was toward that new and stirring element—organization. So far as the original stimulus was concerned, this was necessarily a matter of memory. There were then no Cézannes to be seen publicly in this country except a few small pieces, mainly watercolors and lithographs, shown by Stieglitz at "291." Steichen, who was then living in France, had sent groups of Rodin drawings and Matisse watercolors for exhibition there, and Marius de Zayas was bringing to the same gallery the first Negro sculpture to be seen in this country, with new work by Picasso, who with Braque had made a fresh move and was concerned with a reduction of structure to its simplest forms, in cubism.

The work of Picasso which Sheeler had seen in Paris belonged to a transitional period, created shortly after this artist had consciously

39

abandoned romantic painting. This new irradiated cubism was exciting in itself and also because it offered proof that the movement contained seeds of genuine life: here were fresh phases, positive changes. The turn was important for a young artist struggling for his own speech, but the spell which Picasso cast over Sheeler went even deeper. This work and the movement to which it belonged had still not been subjected to close definition. In a journalistic account of the early English exhibitions which had included Picasso, Roger Fry had used the word "classic" mainly to indicate the absence of those associated ideas which typically belong to romanticism. It was not until Picasso turned to the antique for subject and study that the classic spirit was attributed to his painting. The designation was unimportant in any case but for Sheeler the quality struck home. Even then Picasso's statement of later years could have been used to describe the basic approaches of this work: "When I paint, my object is to show what I have found, not what I am looking for." Sheeler would not have made the same summary, certainly not at this time, yet this harmonious statement of a principle summed up the kind of perception toward which he was working. This is the classical approach rather than the romantic, proceeding from certainties, not from a search for the unknown. Either may be rich, but the outcome differs radically in emotion and character. Sheeler was no longer making a painting at a single sitting; instead he attempted to organize a picture as completely as possible before touching paper or canvas, then worked at it with deliberation. His earlier habit of memorizing subjects was proving of assistance to him in this new attack. In this Picasso exercised no direct influence; noth-

ing of Picasso has appeared at any time in Sheeler's work though he regarded him then and still regards him as the greatest of the moderns. "That inexhaustible fertility of his, and the way he can turn corners, one after another!" For a time Sheeler dedicated himself to cubism, particularly after the Armory show of 1913, but he was attempting to apply its underlying principle, not to follow the special forms defined by any one of the greater figures in French art.

The Armory show provided the great punctuating force of this period. Brought by Arthur B. Davies and others, some of whom were entirely out of the modern movement, it meant a plain acknowledgment that American art was indebted to French art, and set out to provide that influence in full force and let it have its way. Contemporary American painting was displayed with candor at the same time. Naturally with Davies as a prime mover, the group known as the "Eight" of which he was a member—Luks, Sloan, Lawson, Henri, Prendergast, Glackens, and Shinn were the others—had a definite place in the exhibition but they by no means dominated the American section. The academics were not excluded, the younger and more radical painters were given generous space.

Davies, who had seen photographs of Sheeler's new paintings, invited him to send six to the show, among them "White Chrysanthemums," "Landscape with Farmhouse," and "White Tulips" (33). This was his first public exhibition since the trip abroad. He met Davies at the Armory, and a warm friendship developed. The older man offered him one of his rare invitations to his own studio; later he sent Sheeler books and wrote to him frequently. Davies was one of

those personalities whose energies seem to exist in separate compart-ments. His painting might be delicate, idyllic, the record of transitory or idealized moods, but he had great interest in work totally different from his own. Sheeler says that neither his manner nor his comments gave a clew to his companionable force. "He was slender, wiry, with a tightly drawn mouth that hardly opened as he talked. He would sit on the edge of his chair with his elbows closely held to his sides, briefly discussing pictures or baseball." His interest in art often took the form of action, as in the monumental display at the Armory or in his promotion of the work of younger men.

A storm without parallel in the annals of American art broke as result of the great show. The public took it as "an international circus in paint"—a circus infused with lunacy. Milling about through the wide brick-walled spaces which had hitherto seen only sporting events, the display of poultry, or soldiers at drill, the oncoming throngs all but spat with rage or reeled with knowing laughter. Theodore Roose-velt, "writing as a layman," called the Cubists a "lunatic fringe," and another critic thought the theory of lunacy "after all more courteous than the assumption that the Cubists are merely jokers." The public was assured that this art—"perish the word"—had been devised "by poseurs and charlatans who had long since failed to claim the attention of Paris." Thus Americans were being imposed upon. It was of course the "Nude Descending the Staircase" that drew the loudest laughs. An art magazine offered a prize of ten dollars for an explanation of the Duchamp picture; one of the bright answers was that this was a nude descending *with* stairs. That the nude was male was considered a major

discovery; this circumstance had been overlooked because of the popular idea that artists were concerned only with the female nude. Then the attack grew somber. Harriet Monroe called the Matisse pictures "the most hideous monstrosities ever perpetrated in the name of long suffering art." "Neurotic symbolism," "an occult and curious pedantry" were among the gentler phrases. "Believing as I do," said Kenyon Cox, "that there are still commandments in art as in morals, and still laws in art as in physics, I have no fear that this kind of art will prevail or even that it will long endure. But it may do a good deal of harm while it lasts"—like others, he took up the theme of the debauchery of public taste bound to ensue and the inevitable corruption of young American art students. In behalf of the cubists, Joel Spingarn insisted that art was here "recapturing its own essential madness," but his was an almost solitary voice; much of the debate centered upon the question whether American art could survive such an onslaught. Some of the native talent on display was acknowledged to be "of a very lofty order," indeed the word "genius" was used though not as a rule specifically applied, and one writer insisted that the Americans could beat the French at their own game if they chose.

No such opportunity to study and compare the work of American artists had been possible since the exhibition at the World's Fair thirty years before, which offered the peaceful, the pretty, the bright, with occasional huge canvases in the grand manner. A few critics like Borglum came out with the statement that American art was on the whole discouragingly timid. But there was no doubt about the impact: its reverberations were to be felt in American art for many years, in

43

new courage and in freedom of experiment. By no means least of the results of the exhibition occurred in a wave of new associations among artists, though these developed slowly. It was not until 1917 that the Society of Independent Artists came into existence, encouraging latitude through non-jury exhibitions. Its dominating spirits were drawn together in part by antipathy toward the public which had so raucously expressed its taste at the Armory show and toward the critics who had given it confidence. The inclusion of what was construed as a boisterous piece of obscenity at the opening of the first Independents exhibition was a sign, inducing another furor, more solemnities on the part of the critics, and a wide attendance. Duchamp, who was responsible for the appearance of this object, wished to stress the idea that form should be considered as form, apart from its uses or from any name which might be attached to it.

The French influence apparent in the painting and sculpture displayed was proof that the Armory show had been as effective as its supporters had hoped, a circumstance that gave rise to further lamentations. The more radical experiments in American art were now well out into the open with the benefits that airings may give. Theories were promoted, techniques tried and discussed, cliques formed, friendships made and broken: the drift was toward a wider meeting place for artists, and for artists and the public, or at least a common battleground.

Another of the more positive results was the development of important American collections in which the more radical contemporary art, French and American, was included, notably those of John

Quinn, Miss Lillie P. Bliss, and Walter C. Arensberg. Two of Sheeler's paintings in the first Independents show were sold to John Quinn, another to Walter Arensberg. Miss Bliss later acquired one of his paintings, and Davies purchased two drawings. Davies was tireless in pointing out the need of such collections and campaigned systematically among those most likely to form them. They became a strong force, the more so since contemporary American art was almost unsupported by the museums and since dealers in New York were concerned mainly with the foreign product. Quickly becoming known, these new collections caused repercussions of interest among many minor patrons; they meant a broad encouragement for artists, not only because they could perceive that their new work was finding an audience but because the collections permitted them to see the drift of the movement: though these were private they were not inaccessible. A slow and gradual study of their increasing wealth occurred, setting ideas in further motion.

The larger question remained: what were American artists going to do in the long run with the prevailing French influence? They were captivated, there was no doubt about that. Imitations shot up on all sides, and queries arose which had nothing to do with those posed by hostile critics. Some of the individuals involved met and clashed, during a period of four or five years from about 1917, at the Arensbergs'.

On the walls of their apartment were hung pictures of the growing collection—a collection which Sheeler says is "a biography," among them a small Cézanne which Arensberg later lent him for a time, low in key but rich in color, one of the simpler still lifes—a glass of water,

45

a plate of fruit, a portion of a pitcher and a bowl, part of a table. There were other Cézannes, a number of Picassos, paintings by Matisse, Dérain, Rousseau, the picture which had created the major stir at the Armory show, the "Nude Descending the Staircase," and other work by Duchamp, and paintings by some of the younger Americans. The Sheeler was "Barn Abstraction" (34), and later some of his other work was added.

Sheeler had met Arensberg at the first Independents show, and the two became fast friends. A poet, a supporter of new literary magazines as well as of contemporary art, a student of cryptics by which he was seeking to unravel the Baconian mystery, Arensberg was given to self-effacement, as was Sheeler: both were more interested in listening than in talking. On these evenings there was plenty of chance for receptive quietude: speech and argument rolled and flowed in increasing volume. Talk was heard about the new pictures as these were added to the collection; one of the special excitements for young artists was to see this grow. Isadora Duncan came, who had already created in Paris her "Temple of the Dance of the Future," and was said to fill the universe as she danced in gala performances at the Metropolitan in support of the Allies. In her the classic spirit was supposed to have been born again. James Weldon Johnson was there, Margaret Anderson, Robert Parker, Demuth, Stella, Amy Lowell, and many young poets with William Carlos Williams among them. Miss Lowell converted a sofa into a throne and asked questions with a brisk pedantry. "Now, Williams, what do you think of that? Now, Williams, you ought to learn the difference between shall and will."

46

Imagism, that dry, brief concentration upon externals, was edging past its day, but Miss Lowell was anecdotal as to the movement, somewhat selectively so. She struck Williams as "a violently self-centered person on the defensive." "She was there," he says, "and seemed to offer a backing for new efforts but nobody felt that she was willing to risk a nickel on anyone. The opportunity she had to support new ideas and new writers—to be the actual sponsor of a resurgence of effort in her own environment—struck a frost in her intense selfishness and narrowness. She never backed anyone but Amy. No, we didn't get along."

Other crosscurrents developed, some of them taking violent courses, striking shoals. Dada was to the fore with supporters among some of the French visitors. The French group was usually in the ascendant; much of the conversation was in French. Crôti came, Picabia, Gleize and Madame Gleize, and above all Marcel Duchamp, who was in and out through all these years. Duchamp, Sheeler, Arensberg, and Ernest Southard, a brilliant young psychiatrist, became particularly close friends.

Duchamp was then about twenty-five, "slender, handsome, very trim, tense, like a precision instrument," Sheeler says, "with a sly humor. He already had an important collection of work to his credit, but he had declared himself through with painting. Later—as everybody knows—he was to occupy himself with the mechanics of chess playing all over Europe. In these years he was planning and executing some notable works in glass which added a considerable plus to his achievements—abstract forms with their outlines defined by a wire-like

47

line of lead painted on the back of the glass. Large areas of clear glass remained, and when the work was placed in position in a room the observer also saw in addition to the design whatever casual things occurred behind the unpainted areas. The results were interesting in relating mobile to static forms, and the exquisite craftsmanship gave evidence of the remarkable ability of this artist's hand to carry out the orders of the eye."

Always surrounded by a circle, Duchamp created little occupations, sometimes with ten-cent-store gadgets, "ready mades," he called them, "a tin cup, a can-opener, an egg-beater, a strainer, arranging these in irrelevant combinations to which he gave strange titles. His humor never took the form of jokes but twists of expression. He had little booklets printed containing small drawings and unrelated arrangements of words which somehow fell into patterns." Once he took an article by a leading art critic and had it set up in type which at the opening was microscopic and gradually increased in size until the last passages were in an overwhelmingly large face which almost obliterated the meaning. He had a share in a little art magazine called *R-rong-r-ong*, which began life at the time of the first Independents show. He had a finger in most of the foolery relating to the arts in these years. "His inventiveness seemed to be endless. Whatever he touched—even the foolery—had a most beautiful precision," Sheeler says. "That kind of thing seems almost to have died now that Duchamp isn't doing it any more.

"About two in the morning at the Arensbergs' large trays conveying rice pudding and compôtes of fruit would appear, and along about

48

six the Arensbergs would have their place to themselves—for a few hours. Then at night the arguments would begin all over again." These evenings continued until about 1923 when "their home had come to bear a resemblance to Grand Central. They then decided that a little privacy might be a desirable thing, and they made sure of this by moving outside commuting radius, to California."

"As I look back I think it was the French painters rather than the writers who influenced us," says Williams, "and their influence was very great. They created an atmosphere of release, color release, release from stereotyped forms, trite subjects. There was a lot of humor in French painting, and a kind of loose carelessness. Morals were down and so were a lot of other things. For which everybody was very happy, relieved.

"We looked upon the French with a certain amount of awe because we thought they had secrets about art and literature which we might gain. We were anxious to learn, and yet we were repelled too. There was a little resentment in us against all the success of the French. The time had come for us to talk in our own terms. We felt this. It seems odd to say so now. There is an enormous difference between attitudes then and today. We no longer have that sense of dependence."

Sheeler had read portions of "In the American Grain" published in *Broom,* was warmly enthusiastic about them, and exclaimed when he met Williams at the Josephsons', "Here is the man I've been looking for all my life!" And Williams, who knew some of Sheeler's work, felt that he had "looked at things directly, truly. It was a bond. We both had become aware of a fresh currency in expression, and as we

talked we found that we both meant to lead a life which meant direct association and communication with immediate things."

A new intercommunication between artists and writers had begun of which this lasting friendship was a symbol. Williams, Wallace Stevens, and a few other "new" poets had read some of their work at one of the Independents exhibitions. Some of Sheeler's drawings and photographs were reproduced in *Broom*. This relationship might mean—sometimes it has meant—that art took on a literary quality which could be fatal to its intention, but what was lost in this respect was made up in others. For both contingents it brought an extension of audience—a susceptible and interested audience. Each group was tending more often to look at the work of the other, to consider it, stay with it, give it the warmth of immediate discussion. Exchanges of ideas were taking place that might not be reflected directly in either painting or writing but could provide something in the way of a generative force for both. Nothing of the kind had existed in this country since the eighteen-fifties when Whitman and others had met at Pfaff's: but that was a small group, pseudo-Bohemian on the whole, briefly held together. The ferment of this period, say from 1917 onward, was far more widely spread. It represents a definite episode in the history of the arts in this country and is still sustained.

Discussing the position of American artists and writers at this time, Van Wyck Brooks was calling in the columns of the *Freeman* for a "school," by which he certainly meant nothing that could be "joined," but a school as the word has been applied to a group of artists in the past who have not only similar techniques and themes but common

attitudes and similar broad objectives. Brooks, like André Gide, had in mind a hierarchy in the arts, with a few rare leading spirits who would offer direction. Gide mentions a "neutral terrain" which journeymen of the school would provide; from this "terrain" the greater spirits would take flight. "If one were asked," Brooks said, "what it is that keeps the life of art and letters going in the world, one would be obliged to say perhaps that it is not so much the men of genius as the rank and file of workers in the field of art and letters. Who are these workers? They are the artisans and journeymen who have the simple decencies of their trade, who continue at their task even though they know their powers are mediocre . . . who have an impersonal regard for distinction wherever they find it, and whose sole concern is to keep thought and taste alive. It is these men who fertilize the creative life; they are to genius what honesty is to honor, and unless the soil of the popular spirit is plentifully sprinkled with their qualities, a nation can hardly be expected to give birth to great works."

The isolation of the American artist was Brooks's theme, that isolation which had been plain in the early career of Sheeler when, lacking possible guidance, he had chosen a teacher whose ideas were radically at variance with his own latent power. Movements and ideas had been in a singularly formless condition. No doubt the American artist had almost invariably lacked what Brooks has mentioned, the support of strongly defined movements, but he was arguing that schools could be created by a kind of moral choice, that the lesser workers in the arts should submit themselves to the idea that their work was necessarily humble, preparing a groundwork for new leaders. He was urging the

51

devotion which once belonged to the crafts; and his advice, in the midst of our strident individualisms, was heartening; no one has spoken more persuasively against that "spirit of exploitation and self-assertion, of shoddy workmanship and shoddier aims, of private and domestic self-advantage," which has tended to obliterate a true or rich sense of expressive values among us. But because art has been created in some of the great periods within a kind of hierarchy is not a sign that it will do so again; and to suggest that humility on the part of our lesser workers will give body to the arts is to forget, for one thing, that all art is highly concrete, developing through deliberate or instinctive uses of concrete materials in highly concrete ways.

In the past schools have appeared because channels for the use of such materials had long been cut by tradition, largely through the crafts: the journeyman or artisan to whom Brooks referred was of course the craftsman. He could be humble because there was something for him to be humble about; he had something clear to do; something had been established to which he could devote himself. His occupation had its own peculiar satisfactions, he wasn't obliged to be strident. But the sense of craftsmanship even in the handicrafts had been greatly undermined in the immediate period of which we are speaking in this country because of the machine; it would have been hard to know whence to summon those humble craftsmen. Craftsmanship in painting, which had once been common enough even among the journeymen who worked by formula and almost by rote, had greatly dwindled in American art. One of the striking comparisons which might have been drawn from the Armory show was the gulf

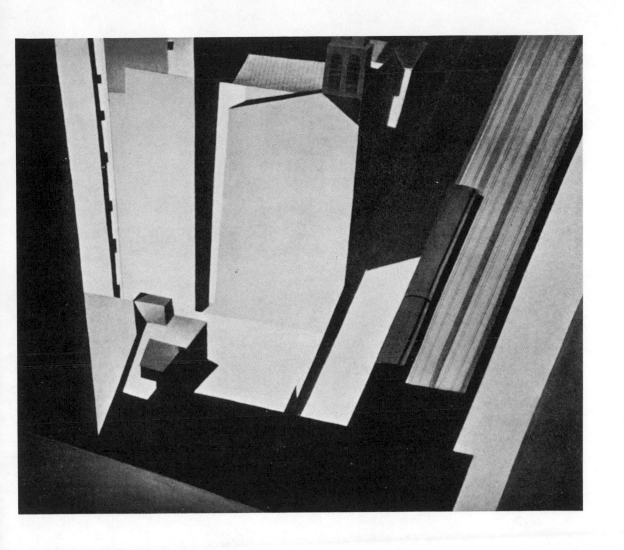

CHURCH STREET EL

53

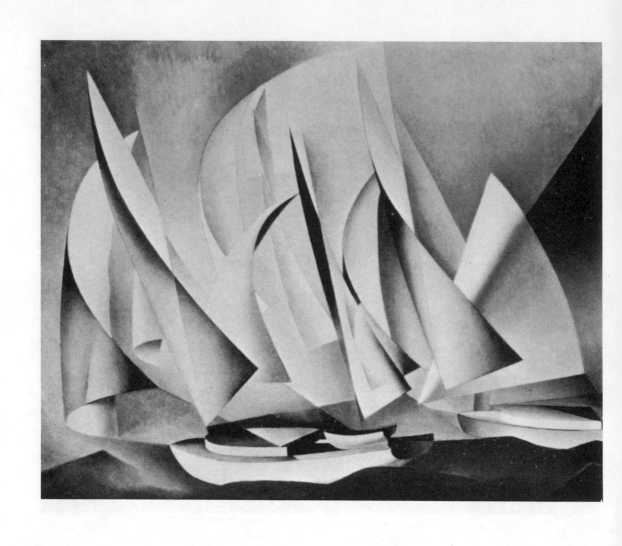

PERTAINING TO YACHTS AND YACHTING

54

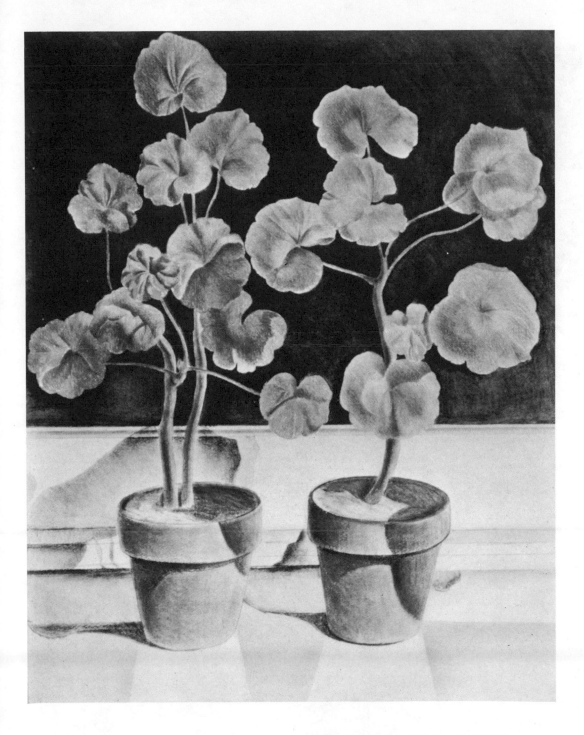

GERANIUMS, POTS, SPACES

55

SELF-PORTRAIT

56

which existed between the French artists and the Americans, viewed as groups, in this respect.

Yet something resembling a movement, if not a school, had developed in which both artists and writers were loosely joined. It was full of flying particles, disparate elements, it was still floated on a vast amount of talk. "Art lives upon discussion, upon experiment, upon curiosity, upon variety of attempt, upon the exchange of views and the comparison of standpoints," says Henry James: yet surely it must draw upon other and more fundamental sources. But what should these be? A turn had been taken toward the American subject in the painting of members of the "Eight" and some others and in the work of such poets as Lindsay and Robinson. Something like an onrush began in this direction, with a much larger preponderance in literature and a marked difference between the two arts. The creative movement in literature was almost immediately accompanied by retrospect. An effort was made to uncover or rediscover our past through new work in biography, literary history, and criticism. This was not always assembled with the intention of defining native traditions, yet these were gradually emerging and were being drawn upon in matters of form as well as subject by new writers.

No similar broad retrospect was occurring in relation to painting. Though the "Eight" and others related to them concentrated upon the American character in some of its livelier phases, as in "McSorley's Bar," their interest was largely illustrational, immediate. Their great virtues were unaffectedness, honesty, and the dynamic rush with which they attracted attention to humble materials. This was impor-

tant but the direction was by no means new. A long wandering detour had taken place by way of Düsseldorf, Munich, Barbizon, and even Japan, but on the whole American art had shown a fair amount of continuity in handling the American subject. What was lacking was a sense of derivations, that sense of the past from which art always in some way springs, even when the past is left behind. Here and there outside actual painting, research had begun as to the older traditions in American art, but this was proceeding slowly, and artists seemed to have had little or nothing to do with its problems.

Even now fairly extensive stretches of unknown territory remain in our art history, and a knowledge of American art of the past is hardly regarded as essential to the contemporary artist. This means no perversity on his part as contrasted with the writer. Our older literature is fairly accessible, but on the contrary works of art have slipped out of sight readily and have often been lost because of our continual migrations: it may take a concerted archaeology to establish their sequences again. Since these sequences are not in view it has been easy to suppose that they lack significance. Inevitably then, our art of the present day is less closely related to native traditions than is our literature.

3

FOR SHEELER the frame enclosing these experiences was the comparative isolation of Bucks County. Philadelphia was the base for everyday work, which still meant photography; he had continued to spend his week-ends painting at the house in Doylestown with Schamberg. Their occasional visits to New York were "fortifying and helpful in presenting a front to Philadelphia. But on the whole we felt shipwrecked. Modern art was considered there on the same status as an illegitimate child born into the first families, something to live down rather than providing a welcome opportunity to introduce new blood into the strain." When Schamberg died in 1918 after a brief sudden illness Sheeler moved to New York, but he kept the house at Doylestown until 1923 or 1924 and used it whenever he could. Aside from his early sketching expeditions some twelve or thirteen years were spent in this region.

The scene was American and provincial, its architecture was plain and spare. The major influence upon Sheeler's work during this period had been French and—in terms of art—highly sophisticated. Yet an alliance existed between these two groups of forms. Ornament had never existed for the builders of the barns and houses. Ornament had been discarded along with other associated values by the post-impres-

59

sionists. The outcome for each was abstract and architectural. A fine feeling for three-dimensional form had governed the placement of masses in the buildings. Their ells and wings and lean-tos, the diagonals of the roofs, their longitudinal volumes had, almost without exception, been securely, if unconsciously, set in strong formal relationships. The post-impressionists had been concerned primarily with the elements of three-dimensional design.

The greater persuasion for a young and comparatively unknown artist would seem to have been toward following the new vogue, particularly after the Armory show, and for a brief period Sheeler did follow it, with a series of abstract drawings and a few paintings of the same order that were exhibited at the Montross Gallery, again through the influence of Davies. American artists were to use these striking new forms for a number of years; they still use them. The mistake has been that they have often adopted the means by which the French were attempting to cut a difficult knot without perception of the strands of which it was composed—without a similar antecedent experience. It is well known that post-impressionism arose as an extreme declaration against the formlessness of impressionism, which in turn had meant an effort to restore natural elements to French painting, particularly in the use of light, after a long period when form had become dry and empty. That is, the modern movement arose as result of a highly special situation within the history of French art; the problems it set out to resolve were essentially French. For us the war between form and formlessness was not an inevitable war. We had had a strong sense of form in our earlier painting; its rise through the eighteenth

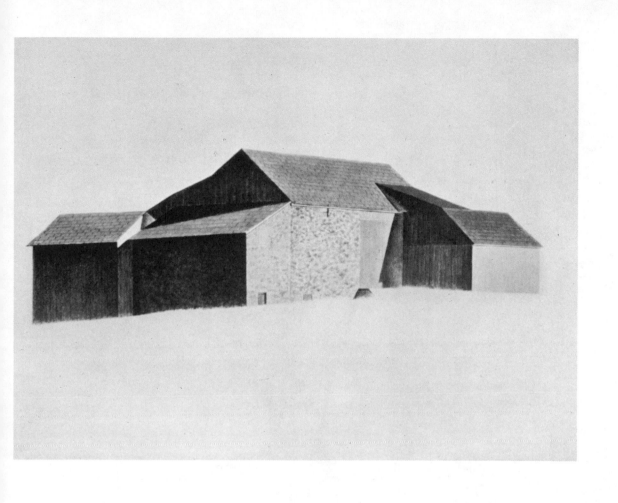

BUCKS COUNTY BARN

61

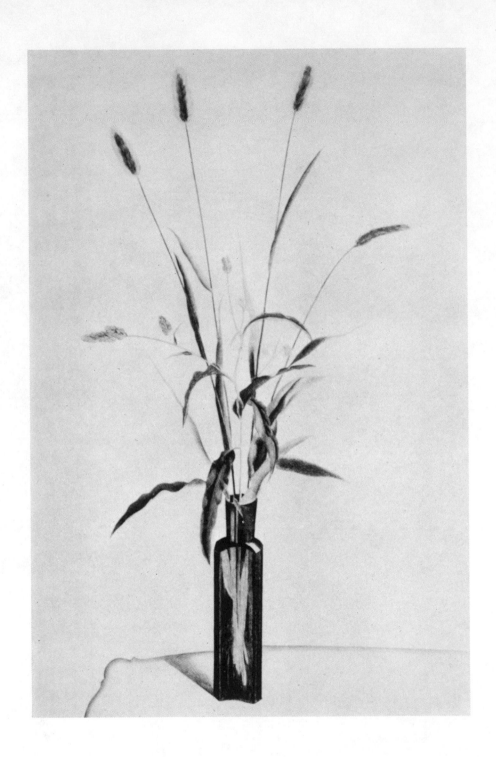

TIMOTHY

62

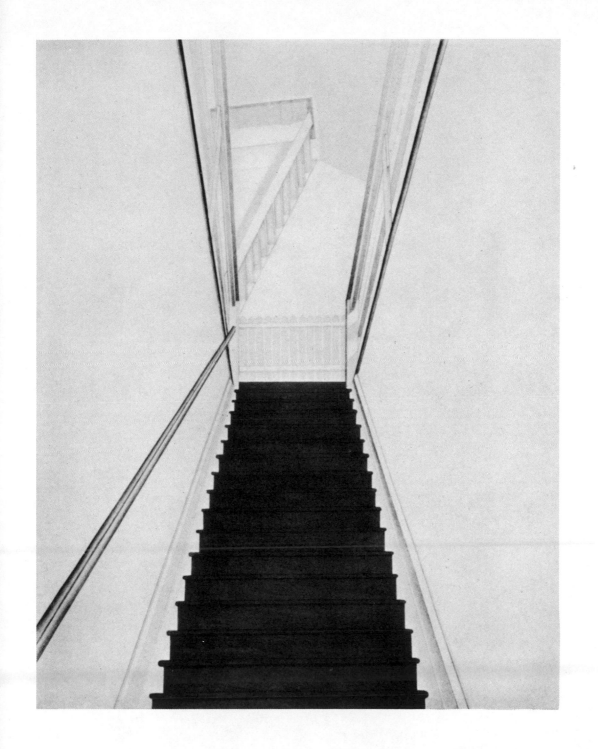

STAIRWAY TO STUDIO

63

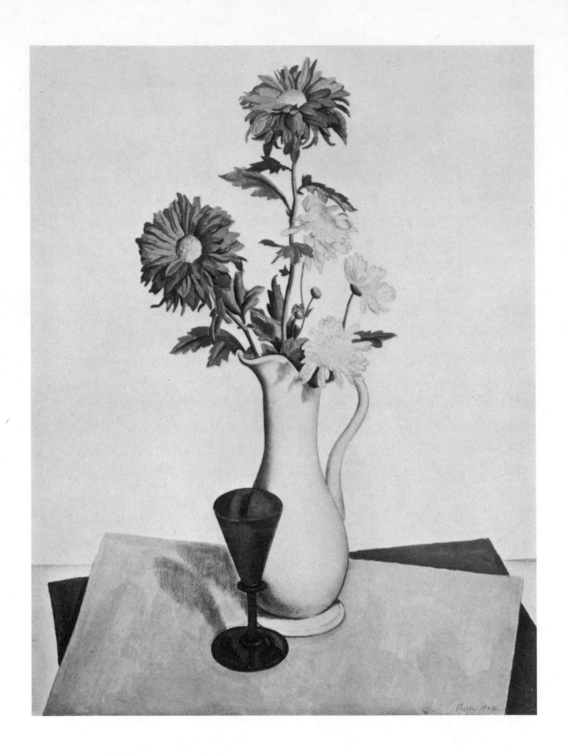

CHRYSANTHEMUMS

64

century and well into the nineteenth, say up to 1850 or 1860, constitutes one of the most striking aspects of our art history, appearing even in its more rustic, provincial phases. But from then on the rapid adoption of many fashions from Europe had meant influences superficially imposed, with a long series of disruptions. When we tried to adopt impressionism, throwing form aside as we did in the Dewings and others, the gesture was meaningless. We couldn't throw aside what we didn't then possess. The wonder is that these soft reductions to nothingness didn't mean a dissolution of the art impulse altogether.

The young French artist could take the plunge into extreme forms of cubism with a sense of renewal, a conviction that he was participating in a long and lively drama. American artists could have no such conviction. They lacked the necessary clews. Their work was suspended in a void and often was a void. They adopted a manner but did not find their way, in the main, into the essential creative problems involved. The difference was indicated by the results. French cubism had a certain gaiety as if its authors had got up early in the morning for a run around the cinder track to put themselves into condition— and also for the pleasure of it, a combination that makes for permanent values. Our cubism tended to be studious, literal, ponderous. A major difference lies in proportional ratios. Ours tended to be simple and unvaried as against the quick ringing of changes in ratio which have belonged to the best of the French work. When cubist forms have been combined with natural forms in our painting one often feels that they could be removed from the picture without loss and very

probably with gain; they seem to have been superimposed. This is by no means to say that American art cannot or should not submit to foreign influences; all art has borrowed from other art. Coming at a time when new impulses were stirring here, undoubtedly cubism pointed the way toward a consideration of those structural elements which have belonged to all great art. But the question remained whether we could appropriate these influences and transform them into terms which were genuinely our own.

Sheeler discounts altogether the brief phase of his own painting in which he used cubist forms and pure abstraction, though a few of these works, particularly the oils, have a touch of that gaiety in color and design which was often carelessly achieved by some of the French artists of the same period. He quickly moved on to work that indicated the main directions which his later art was to follow. Some twenty pieces, which included both painting and photography, were shown at the De Zayas Gallery in New York in 1920. As it happens, they made one of the earliest exhibitions in this country in which photography and painting appeared together on an equal footing.

Abstraction was by no means abandoned in the paintings. "Flower Forms" (35) was linked with the experiments in the purely abstract but differed from them in the intense concentration upon volumes, here as richly rendered—in greenish blue, burnt sienna, and creamy white—as though the subject were being set down in literal detail. "Lhasa," the sacred city on a hilltop, is presented in the same fashion. These paintings, fanciful in character and even in a sense fantasies, made a transition toward another series of some eight works in tem-

66

pera, oil, crayon, of Pennsylvania barns called "Barn Red," "Barn Contrasts," or bearing similar abstract titles. Some of these are two-dimensional except as the third dimension is produced by the firm texture of stone or the curve of a silo. All of them are presented in space, without surrounding contexts, and they are extraordinarily beautiful in color, with reds of great clarity and depth, with the many colors of the limestone playing their refractions; the blacks and whites are both positive and exquisite. These works are all partially abstract. In them all, as in "Barn Abstraction" (34) the basic concern is with form. Their secrets lie in the undiscoverable ways in which the oblongs and squares and cylinders containing stone or clapboarding or shingles are placed so as to result in a continuously flowing balance.

Included with this group was a painting which even more obviously forecast well-known phases of Sheeler's later work: "Hallway" (36) —the hallway of an old house with a rising staircase, in oil. The color is strong—deep blues for the stairs, sienna, warm black, and white or cream: these are used abstractly; the blue of the stairs might be carpeting, but it rises in an unbroken abstract area. The window frame, the stair rail, its spindles, belong both to realism and to abstraction: they are revealed by line yet they are set within three dimensions: the whole keeps the solidity of direct representation.

As for the photographs, one of these at least could stand alone today as a measure of Sheeler's accomplishment as a photographer on the technical side, in choice of subject, in attitude toward subject. This was "Side of a White Barn" (189) which again derived from Bucks County. "Sheeler was objective before the rest of us were," Steichen

says, and this photograph, made about 1916, is there to prove it. The theme is simple, prosaic even, yet not stark; here is a simple poetry of surfaces, light, line, and volume. The white wall in wood makes the subject, rising from a plastered stone base, seen directly, close at hand, the upright planks joined by vertical cleats; the whole is drenched in sunlight. That is all: yet here is a complete revelation: the palpable light, narrow shadows, the rise and strength of the planks, their splits and knotholes, the fine gradations of white, the substance of wood as it feels to the hand.

At this time soft focus in photography was still in favor. Sheeler had taken the opposite direction. This early work like that of later years was fresh and clear, with a strong sense of inherent design and a rendering of textures which has been unsurpassed. Other photographs shown in this exhibition, of an Indian painting on skin and of a tissue paper lampshade, had the same objectivity as "Side of a White Barn" and showed the same technical accomplishment in the rendering of textures and the full character of form.

The exhibit was hung in a gallery containing no draperies or rugs, where plain cement floors and white wall spaces set up no conflicts with the pictures, which were framed in thin strips of wood. If simplicity, objectivity were desired, here they were in full measure. This presentation was fortunate, but the exhibition created no particular stir. One critic spoke of "this artist's rural tendencies" and called the Bucks County barns "uninteresting models," thus providing sneers without which no major artist's early career would be complete; but he admitted that "Sheeler can draw, and knows color."

68

In some undefinable fashion this work was unlike that of the French cubists—where then was a standard for judging it? Sheeler had taken his own line. Throwing aside what he had felt to be false in his earliest painting, he had studied the powerful French figures, but he still had not yielded to them: he had submerged their influence within his own intentions. The fact that he had chosen an American subject was not in itself significant, for subject alone is never a solution for the artist. Certainly the American subject has not sufficed to create a strongly defined American art; if this were true we would have had the substantial fiber of a tradition almost from the beginning. The departures would not have mattered. The determinant is form. It is by the use of form that the individual artist makes his art distinctive. It is the consistent print of form in successive periods which gives a national tradition its character. This broad print, almost tactile in effect, is nothing fixed; it may waver and vary; but even comparatively small and minor traditions will consistently betray it.

In turning to architecture Sheeler had discovered forms that were basic in American creative experience, *Urformen*—forms which for us are source-forms. Of all our inheritance from the past our early architecture has most to say because its lineage is long, because its materials have tended to be durable, leaving their print in terms of form upon the successive generations which have used it. The simple buildings of Bucks County had their counterparts in many places, which differed in detail but not in basic character. The impulse that constructed them reappeared in the New England frame farmhouses and barns; stone cottages in Maryland are allied to both groups as are certain

69

one-room slave houses in Louisiana with medieval roofs and severe outlines, built of cypress. The formal distinction of many of these buildings has remained hidden because of their humble use, but they expressed native taste uncorrupted by the *luxe* that quickly invaded architecture on the large scale.

No effort seems to have been made in building these small, homely structures to follow ancestral styles; when traces of the past appear it is with radical simplifications, usually with so complete a reduction for new purposes as to constitute a complete change. Within their construction lay an emotional force that might be lacking in the work of an accomplished early portrait painter of the same place and period. Obviously the impulse that created them is one of the most fundamental of human impulses: to find roots, an abiding place. Sensuous quality belonged to them; the very absence of ornament permitted a directly sensuous expression through beautiful surfaces, fine line, well-wrought structure. In these unpretentious buildings nothing was created for its own sake; all was a means to an end, a portion of the whole. Craftsmanship was of their substance; only by accomplished adaptations of hand and eye could these buildings have been so strongly developed. Their seeming irregularities, the placement of windows and doors, the proportionate ratios of line and volume were carried easily—in the finest examples buoyantly. The final structure had almost habitually an extraordinary unity—that final unity which we call classic.

The classic in this country is usually considered to mean the classic revival, which ran a broad course through our early years, fancifully

associated with what was believed to be the democracy of Greece or Rome in the great periods. Perhaps its forms were appropriated the more eagerly because they seemed to give permanence or balance in the midst of the hasty turmoil of pioneering, or to assure us that we might cultivate these qualities. The idea was afloat that we were to emulate the Golden Age in our rising civilization. In fact the classic revival represented one of our thoroughly romantic aspirations. The illusion passed—in part—but the forms remained, like rituals whose meaning has been lost and they have come down the years in increasingly debased, empty, and tarnished guises.

It may even be argued that we have never had a classic art in this country, that our broad drift has been toward romanticism; it could be said that we *were* the romantic movement during the nineteenth century and even earlier, an embodiment of those explosive, highly individualistic forces expressed by romantic art and literature during this major period in Europe. Indeed the stresses and strains of romanticism with their assertions, boldness, and breadth were characteristic of much of the life and expression on our frontiers; they belong to those phases of the national character which we are most likely to call American. In romanticism emotion outruns tranquillity and upsets it; change is a touchstone; the past, when it is drawn upon, is not regarded with serenity but with nostalgia.

Classicism accepts that which has been discovered; it is rooted in tradition, though if it is a living force its accepted inheritance will be freshly transformed. Romanticism forms a great errand toward discovery: Whitman is a complete expression of this spirit. If no similar,

71

broadly luminous figure has appeared in the development of American painting some of the same cluster of qualities made itself felt in the wide areas of Trumbull's landscapes, with more emotional intensity in Cole's and among other members of the Hudson River school. Dynamic force was absent from these works but the typical romantic expansiveness of spirit belongs to them.

In celebrating the romantic forces in our civilization we have sometimes overlooked the serenities, securities, and permanences that appeared even on our frontiers. We have thought of the frontier as forever on the march, moving tumultuously westward, yet it often seemed to those who reached it a resting-place that would endure forever. Some of its communities became, if only for a brief space, little islands of tranquil yet highly keyed existence, particularly in the long colonial era, perhaps even up to 1820 or thereabouts when the more sweeping movements westward began, sometimes even later. Tranquillity and balance were sustained there by close identities of race, religion, and memory, and by the immediate communal experience of settlement. Here was appeasement after long unrest, a sense of grateful possession, a genuine freedom—freedom to exist within an established mode. The communal or social was of the essence of this consummation, and naturally its character was most freely expressed in architecture, the most social of forms, often running through a whole series of buildings; but it appeared as well in the fine craftsmanship devoted to the plain utensils of everyday life, hearth tools, trivets, skillets, textiles, even plow handles or carts, in the glass or pottery made in small local works, all of them objects used in strongly established modes of

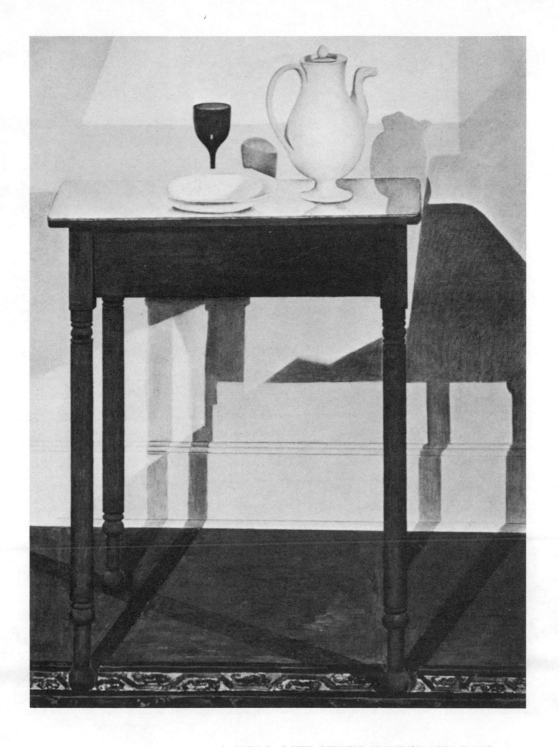

STILL LIFE WITH WHITE TEAPOT

73

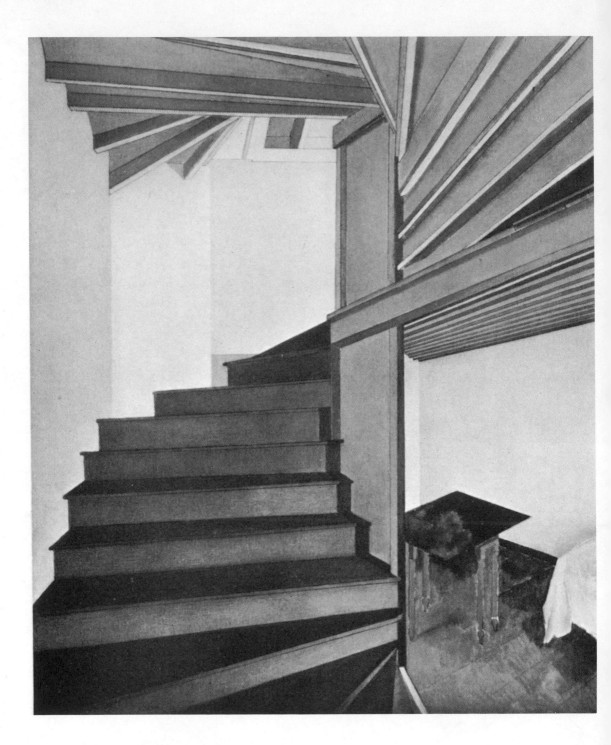

STAIRCASE, DOYLESTOWN

74

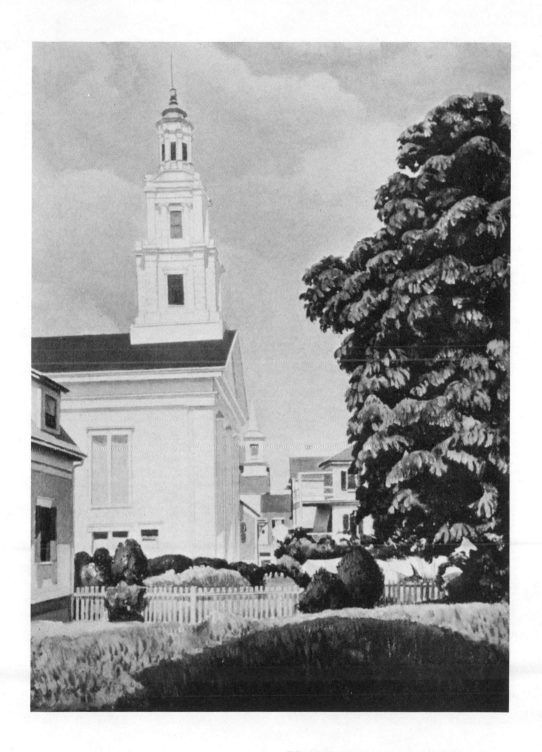

PROVINCETOWN CHURCH

75

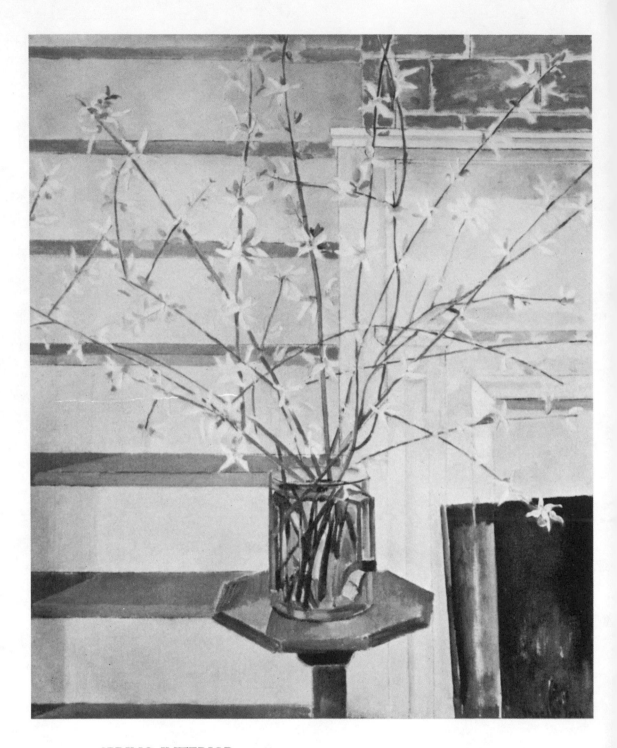

SPRING INTERIOR

76

life which were sustained, though they were often simplified, in these new places.

These quiet arts were neither casual nor infrequent. They appeared with great clarity and precision in many of our early communes, as at Ephrata, and notably among the Shakers, who sustained their fine and equable use of the crafts over a long period of time. The crafts developed not only on early frontiers in New England and Pennsylvania but much farther afield. A village high on the bank of a Michigan river whose builders came in the eighteen-thirties from upper New York state, with ancestries farther back in New England, revealed these qualities without a break, with extraordinary homogeneity, until a summer invasion began about a dozen years ago. The classic in this country may still be found in many places if it is sought without prepossessions of magnitude or grandeur. It has often been overlooked; one surmises that much of it still remains to be discovered. What we have failed to realize is that the classic has nothing to do with grandeur, that it cannot be copied or imported, but is the outgrowth of a special mode of life and feeling.

Thus Sheeler was tapping main sources by his use of architectural forms in Bucks County and likewise by his more or less conscious study of the handicrafts which he found thereabouts. We have usually been ready enough to admit that we lack traditions though our accents have varied as we have made the statement. In our earlier years we sometimes said this with pride, with confidence, assuming that we didn't need them, that we could create all the arts afresh, from new sources, and in a grander style than the world had ever

77

known. Nowadays we have gone to the other extreme, believing that we have no traditions in the arts worthy of the name but must look to Europe both for guidance and for ancestries. In our more hopeful moments we have supposed that something vaguely called the American spirit may infuse our art and literature and make this recognizably our own. At another tangent we have thrown the idea of nationalism out of the window and have insisted that art is an international language. So it often is: but no art has ever reached the point where it could speak a world language or even a hemispheric language without an ancestry of local or provincial expression behind it. This may not be completely original, but—if we are to judge by the remaining evidences—it has always taken on a special native fiber before it assumes the greater breadth.

Have we had this fiber? Do we possess a lineage of our own? Sheeler had made his own reply to these questions though they had not yet been broadly asked, not at all in the sense in which they are being asked today. His choice was instinctive; certainly he had no guidance in this direction; the rush toward the "early American" in architecture and the crafts which was to take so many forms had not yet begun. Still less had architecture been considered a wellspring for the artist—if it is even now so considered. The strong character of these buildings simply as architecture had been overlooked.

He had found a subject which was to reappear in various guises in his later work, as absolutes in form and as substantial realization; and he had begun to reveal what at a later date was to be called "the American scene," as distinguished from the American subject—the

78

outdoor scene upon which American life had left its print. He was among the first to make this choice, branching away from the work of the "Eight," who had been concerned mainly with interiors, and also departing broadly from the landscape painters. But the deeper implications of these early works by Sheeler lie outside subject, as has been said: they have to do with form. Though he used the modes of expression which he had learned during his brief stay in Paris and later at the Armory show, those of post-impressionism, of cubism, his uses were determined by the proportionate ratios, the materials, and the final design of the provincial buildings at hand. In other words he had submerged French influence within his own expression. He had sustained native forms with peculiar integrity. For the eye sensitive to formal differences this becomes clear if this work—or his later work—is compared with French art in the same modes: they speak a different language.

There is no diminishing this achievement. Sheeler had made himself a pathfinder in the use of American traditions in art, and what he accomplished was the more striking since it was a solitary venture. That there was nothing narrow or doctrinaire in his choices was shown by his immediate response to another major influence, one which had had its effect upon the modern movement abroad, particularly upon Picasso, and was to have many repercussions here: that of primitive Negro sculpture. Indeed this preoccupation on Sheeler's part quickly widened toward other primitive forms.

In 1920, when the name of the gallery was changed from the Modern to the De Zayas Gallery, Sheeler became an associate there,

79

taking charge when De Zayas went to France not only for work by the French modernists but examples of primitive or ancient art. In Mexico—he was a Mexican—De Zayas had known well the architectural sculpture of the Aztecs; some of this was always to be seen at the Gallery, and his interest amply extended toward other so-called primitive art. The Gallery was never without Negro wood sculpture from Africa, mainly masks; and Chinese carvings in jade and Chinese paintings were also shown there.

These objects had formed a context for the exhibition of Sheeler's work in 1920; he had indeed been greatly attracted to them during his occasional earlier visits, and while he was still living in Philadelphia had made a series of photographs of the Negro masks to please himself. They were grouped in portfolios for which De Zayas wrote an introduction; twenty-two copies were printed. Later Sheeler photographed other examples of this sculpture. A reflective, truly morbid mask is among them, with delicately tattooed tracery beneath the eyes. Another is dark and eyeless against a void, beyond emotion. Another suggests pre-Phidian sculpture. Another has a highly polished, sensitively surfaced beetle-like form (190).

One of these photographs, that of a sculptured musical instrument, was widely remarked at the time because of an unusual technical accomplishment: the curved surface hidden from the spectator was shown together with the direct view by means of shadows contrived through posing of the piece and through lighting. Technically the whole series is of the highest order. The photographs are fully sculptural in presentation; they could only have been produced by one who

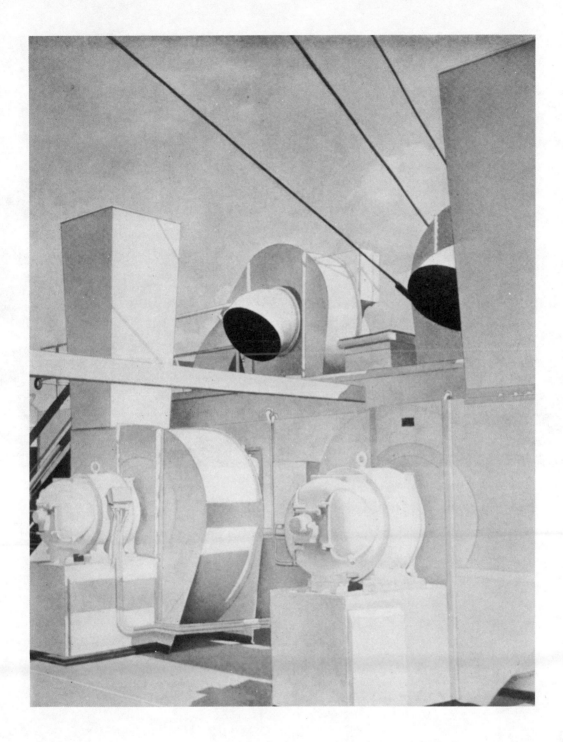

UPPER DECK

81

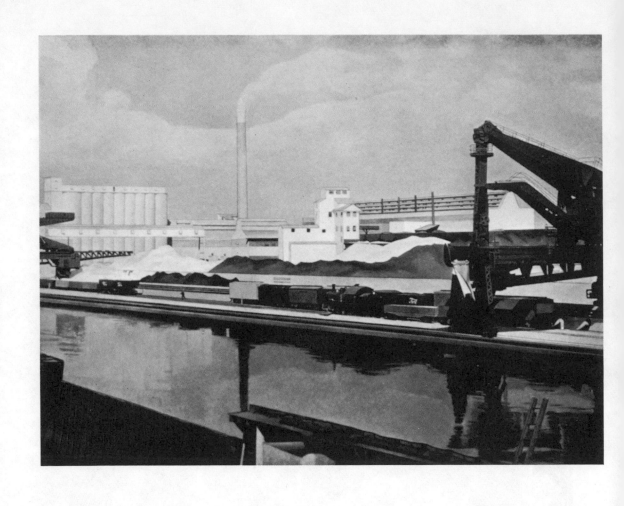

AMERICAN LANDSCAPE

82

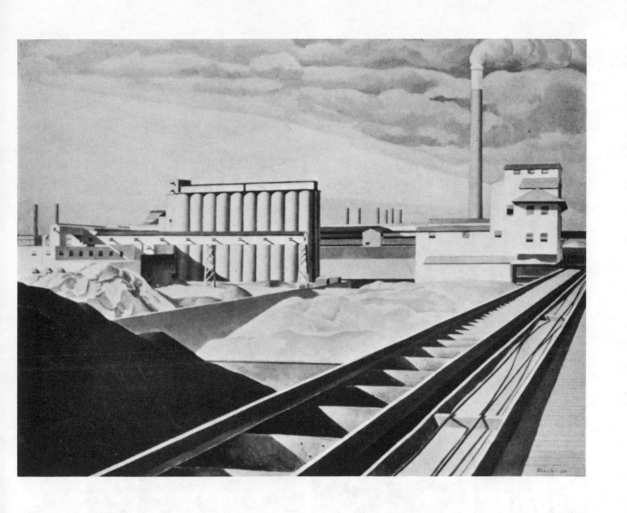

CLASSIC LANDSCAPE

83

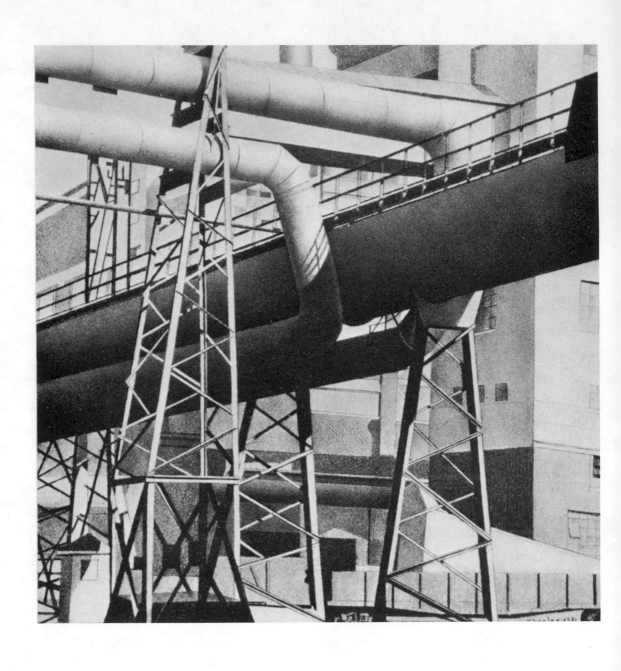

BALLET MÉCANIQUE

84

understood that the exquisite elaboration of surfaces in the originals was significant only for the underlying plastic values which they could express. They represent indeed one of the great series in American photography and rank the higher because their finely objective clarity was still generally unsought in the photography of the time. Their achievement matched on a wider scale that of "Side of a White Barn."

During his first years in New York, while he was at the De Zayas Gallery and after this closed, Sheeler supplemented his other work by photographing works of art, mainly Chinese jades, porcelains, and paintings in some of the great collections. The Chinese series is hardly less significant than that of the Negro masks, and possesses the same qualities. All these photographs have something more than precision of rendering; they reveal a passionate concentration which has been considered the property of art alone—something that may without too much exaggeration be called dedication to the object. To study them is to know that they occupied something more than a casual place in Sheeler's work as an artist. Here was another of those episodic influences from which it has been easy to argue that our art is a hybrid. These Negro pieces quickly gave rise to a cult, with more than a few sculptors tending to appropriate their bizarre externals, translating these into grotesque, fore-shortened legs or submerged arms, flattened planes, imitating in other words the accidental elements and sometimes the lesser examples of this art, missing the plastic organization and the unity which made the finest of these pieces nothing short of miraculous. No mirroring of any of these concrete forms appeared in

Sheeler's painting then or later, no similar embodiments of formal organization. They meant for him a furtherance of interest in three-dimensional form, in precision of line, a sharpening of the consciousness of surfaces, of plastic elements.

These perceptions were furthered by talk—the talk that went on endlessly in the clear spaces of the back room at the gallery. De Zayas, restless, dynamic, theoretical, was always passing beyond these works to general questions about them. How had primitive art originated? What was its basic force, its secret? As to the Negro sculptures there was not a great deal to go by, only the smallest body of difficult evidence on the anthropological or religious side. For Chinese art of the great periods many annotations could be found. De Zayas expounded the quietist philosophy of Lao-tse with its many corollaries for art and life. The place of individualism in great art became a theme, and whether the greatest art is personal or impersonal. Since Picasso had turned to Greek classicism, it was easy to consider Plato, with his derogatory judgments of the artist brushed aside for arguments about timelessness, permanences, and the abstract or generic rather than the specific in art. De Zayas, well known as a caricaturist, had used some of these distinctions long before in relation to his own drawings, which he divided into two classes, "absolute" caricatures and "relative" caricatures.

Stimulated by these ideas, Sheeler pored over Jowett's stout volumes. Matthew Josephson tells a story of this period—which Sheeler declares is apocryphal. The artist, Josephson says, arose at an early hour and viewed a tree, first from one angle, then at another, finally

walking round and round it, considering not the specific tree, not a maple or an oak or a willow or whatever it was, but tree as tree. "Do you think he was getting ready to paint that tree? No, sometime he was going to paint *a* tree."

The air was full of abstract theory, as was inevitable at a time when old forms were breaking up in an age that was essentially self-conscious. What was art after all? The old question kept its perennial freshness, and the answer was being the more eagerly sought because the modern movement still seemed to many individuals a denial of first principles. In the popular view, post-impressionism was being related to jazz, which was then coming into a full vogue, and the backward reach to Greek, Egyptian, Persian, and Negro art seemed only a declaration of bankruptcy, the effort of a false exhibitionism to maintain itself by novelties. Yet the return of the modernists to the many forms of antiquity was surely in part at least an effort to find an answer to the primordial question. They came upon finalities in terms which they well understood, pristine forms in which everything was eliminated that did not belong to a direct expressive purpose. It was only superficially that this search became exoticism. At bottom it was another phase of the broad return to the classic.

This return, it must be noted, was not to painting but to sculpture or ceramics. If it seems a far cry from Aztec or Assyrian reliefs, from Greek or Negro sculpture, to the humble architecture and tools of some of our frontiers, that may be because we underestimate our own wealth. All these forms, from the Aztec to the Pennsylvanian had what may be called structural truth, and a singular unity. Undoubt-

edly by his participation in arguments on related questions Sheeler earned the designation "an intellectual artist prone to theory," as a critic called him at about this time. Yet understanding of any of these works is essentially not intellectual; they are too emotionally single for that. What he gained from this ancient or primitive art was reinforcement for choices he had already made.

4

WITH THE ESTABLISHMENT of so distinctive a group of subjects it might be supposed that Sheeler would use these consistently, but he has never had a calculated program. His typical procedure has been through groups of paintings radically unlike in subject and often in handling. His new work became clearer, more dramatic, more intense, but its immediate themes were of quite another order from any of those which he had just been exploring.

Upon moving to New York he had collaborated almost at once with Paul Strand in the making of a motion picture called "Mannahatta," a portrait of the city that was one of the first to employ a variety of perspectives within skyscraper canyons. The captions, as the title indicates, were taken from Whitman, and though the film was unsupported by commercial interests it was shown extensively and with considerable success as a short in and around New York, and later was exhibited privately in Paris as an evidence of American modernism, appearing as part of a Dadaist program which included music by Erik Satie and poems by Guillaume Apollinaire, and receiving something of an ovation. It has occasionally been revived in this country.

In subject, "Church Street El" (53) is an outgrowth of work on

this motion picture. Here are the canyons, the heights, and the downward view which they compel, but the series of glimpses has been transmuted into a composite; instead of the accidents of form belonging to photography we have generic and vibrant structures within a concentrated focus. The motion of the elevated trains seems to create the tempo, the character, the visual force of the picture. As is right, the elevated tracks remain an underply, positive but low in key; they are discoverable comparatively late in the journey of the eye; they do not vanish, and it is one of the technical triumphs of the picture that this is so. It is also a triumph that the trains move either way as the eye returns to them at one time or another, and that the relentless shuttling movement thus induced, out to the rim of the canvas and back, makes a culmination for the experience of the spectator.

Chasms, ledges, windows, and roofs—all these complex forms are apparently presented with simplicity; their apparently guileless diagonals determine the force of the picture. "I used an intentional reverse of perspective," Sheeler says, "placing the point of greatest concern close to the position of the spectator, well down in front, rather than at some distant point on the horizon. In a way the picture includes the spectator, makes him a point of focal attraction, gives him importance. This arrangement was not my invention of course. Some if not all of the Orientals have used it." The passage of greatest intricacy occurs around the church steeple, at the usual horizon edge where as a rule simplification is used. Light, which falls obliquely on this congeries of abstractions, is in itself abstract—a kind of absolute light, belonging

to no special time of day. Yet the underlying severities of structure are defined by it. The color is arbitrary though close to actual possibilities: pinks, blue-browns, two keys of pale yellow, dark gray, blue-gray.

The final test of the originality and power of this comparatively small canvas is the compulsion which it exerts upon the spectator to return and return again to discover new variations in form which may have escaped him at the first view or after a number of views. He will find himself interestingly involved with one passage after another, and he may also occupy himself with the question how the artist has managed to convey the effect of volumes by means of what seem to be flat planes. Dimension seems to be developed by almost imperceptible brush-strokes and modulations in tone.

In immediate sequence appeared a crayon and an oil, both with the same title, "Pertaining to Yachts and Yachting." At first glance, structural identity between "Church Street" and the "Yachts" may be suggested because of the use of diagonals, motion, abstraction, but the pictures are radically different, even beyond the obvious differences produced by the curves and parabolas of the subject in the "Yachts." Motion in this picture is the motion of wind rather than the conditioned motion of the elevated, and abstraction is modified; the forms are close to representational forms. They have satisfied the weather eye of yachtsmen. "That's right," they have said. "There is someone who understands yachts." As a matter of fact Sheeler did not go near a yacht in preparation for these pictures and is rather proud of it, but collected data from books, went through files of photographs, threw

91

away the detail, and evolved his first picture, the crayon. It is more abstract than the oil, very blonde in color, showing not sunlight but a concentrated abstraction of sunlight in the interstices of yellow between the sails; set against this is the vibrant blue of the sky. In the oil (54) diagonal planes of light and mist have been let into the design and the color is deepened. The sails run from broad white into ivory, cream, with deep burnt brown for the shadows; the boats are burnt sienna, the water greenish blue, the boat shadows go down to blue that is almost black. A few years later Sheeler made a lithograph —all of his small number of lithographs are in black and white—which uses closely similar forms but creates a wholly fresh arrangement.

Here are the forces of wind, water, mist, strongly prismed light, multiple transparencies, the riding motion of boats and the slap of waves, the varying bodies of sails and hulls, rendered as pure design yet with no sacrifice of underlying truth; rather the broad use of design heightens the effect of the natural forms. Borrowing from the language of imagism, Sheeler speaks of the "Yachts" as "studies in polyphonic form." All three pictures are just that, presenting images similar to the point of repetition yet with crystalline changes and differences. The basic observation is both faithful and poetic. The concentration heightens both elements, poetry and representation.

In "Geraniums, Pots, Spaces" (55) abstraction has been sunk beneath the surface of the picture. The subject is homely, the arrangement casual; the design in this actual-size crayon derives from the irregular forms and shadowings of the geranium leaves and of the pots, which lead to sequences, variations, contrasts within the whole pic-

ture. Unstudied as it seems, the arrangement contains the play of a rich formal order. One would say that it is nearer to a still life by Chardin than one by Cézanne in its feeling for the qualities which may inhere in humble objects.

The emotional element in Chardin? The element of feeling which most modernists consistently deny? As Raynal has said, painters somewhat typically insist these days that they are only painters, that they are concerned only with concrete subjects in a concrete medium. A certain amount of risk now attaches to attributing any but the most general emotional qualities to a work of art, so strong has been the reaction against those broad suffusions of sentiment which have governed interpretations of art in the immediate past. Obviously it is not within any artist's power to pour emotion into a work. "I try to concentrate as much as possible upon *emotion* when I paint," says a young artist with an engaging look and a driving swirl of the fist that almost goes through the canvas: but this specific intention seems the likeliest way to keep emotion out. Emotion or the lack of it cannot be concealed in painting if this has existed or been absent at the source, though its character may not always be apparent at once in an original or subtly developed work, where the idiom must first be understood, the statement comprehended before latent values in feeling can come through; and the statement of a genuinely original artist is constantly changing. It will not be subject to simple or sweeping interpretations.

Marked contrasts in emotional quality are clear in this first group of Sheeler's work completed in New York. An unsentimental tenderness or regard belongs to "Geraniums," a resonant buoyancy, gaiety

93

to the "Yachts." At a far remove "Church Street El" is a dark and brilliant phantom, an eidelon—an image which may be compared without too wide a stretch of the imagination to one of the Negro masks. It is cryptic, fatalistic even, as against the assurances of "Pertaining to Yachts and Yachting." The hazards involved in defining such elements in a picture spring from the fact that words, which most of us know better than we do the language of art, are often strong enough to obscure the primary visual qualities of the given picture; and their associations may be confusing. In Sheeler's paintings the core is concern for the subject—the whole subject; personal feeling is floated within that essentially impersonal emotion. Van Wyck Brooks, protesting against that self-advertisement on the part of artists and writers which he felt had put a blight upon serious work in our time, was insisting in these years that great art is always impersonal. Certainly this is true of classic art, in which personal emotion is never self-insistent. It makes no enclosures for its themes; a special emotional pleasure which it conveys comes rather from a sense of freedom, of release from purely individual feeling or concern.

One of Sheeler's pictures of these years, from 1920 to 1924, may be taken as an allegory on this theme though it was certainly not created with any such intention and is susceptible to other readings, and has had them. "Still Life" was its original title; this was later changed to "Self-Portrait" (56). Soon after this crayon was exhibited it appeared in F.P.A.'s column with the implication that the artist's intention was facetious. In an exhibition in Paris it was considered a highly controversial picture. Marcel Duchamp, who with an extraordinarily

rapid eye and mind could usually exhaust a picture in a few minutes, stayed with "Self-Portrait" for some time, finally declaring himself: "I like it." Whenever it has been shown it has provoked argument. It apparently contains an element of fantasy which appears nowhere else in Sheeler's art except perhaps in an occasional digression in some secondary passage of a picture. The immediate controversy arose because of the inclusion of a telephone, which was considered so "contemporary" as to make it an unsuitable subject for art; the picture was called "resolutely inartistic" because of it, or at best, "a novelty."

The subject of course is not the telephone but the whole visual episode in which it is found, within the whites of the table and the window frame, against the black of the glass with its reflection of the seated figure of the artist, all brought into relation to the white cord and the patternings of its own black cord and the shadows made by this in turn. The picture seems exceedingly simple. Stay with it a while and you will find that it is not. It apparently contains a fable, but the special accomplishment lies not in this possibility but in the delicate complexities of the design, in the almost imperceptible means by which the table is given solidity, the arrangement of line and shadow against white, with the dark rectangle of the window-pane kept unaccountably within the picture. Logically it shouldn't stay there, and one can hardly discover why it does. The whites below should rise and bubble against the dark, yet their balances remain clear.

This achievement is as difficult as any meaning that may be read into the drawing, but if one must have meanings they may be devel-

oped from the fact that the artist remains in shadow, only partially portrayed, and that the cord is there to pull down the shade at any time, covering even that ephemeral glimpse. If one chooses to go farther one may infer that he does not speak directly but through an instrument. His self-effacement is practically complete. This happens to sum up the relationship of the classic artist to his subject. He is himself the instrument; individualism is by no means excluded but it is not stressed. He reveals but he does not insist. He is speaking of an underlying order which he has discovered in his theme.

It is not the subject which creates the outcome, that final and deceptive simplicity which belongs to classic art: it is the way in which the subject has been perceived. The classic subject is no more a determinant than is any other subject; if this were true the innumerable little oils and watercolors of the Parthenon studiously achieved by traveling ladies would have brought about a world-wide classic revival. Nor need the subject in itself be simple; it may be as complex as that of "Church Street El" or as casual as in "Timothy" (62). Classic forms, if they are to survive, must constantly be transmuted. Sheeler had struck through to classic feeling in a wide range of fresh subjects, which was proof enough of the security with which he had found his direction. The forms might be polyphonic or not, the subjects might or might not possess an intrinsic classicism, but the perception of an irreducible final order was the same. In "Timothy"—a crayon drawing in pinks, browns, greens, rosy-browns—no subject could be more simply placed, but discover if you can the logic in contour of the exquisite line suggesting the table, or why this gives final

unity to the uncontrived little group, or why the whole is structural in its own special fashion.

In the picture which followed, the artist rounded back to a primary theme, "Bucks County Barn" (61), which swings between realism and abstraction and is all monumental structure, all purity of outline, drenching sunlight, strong formal shadow. Light is here a primary theme like the solid limestone of the walls. Everything accidental has been eliminated. The concern is for absolutes. If Sheeler again wished to be enigmatic he has accomplished his intention here though not by presenting a fable but because the secret of design cannot be unraveled. Simple as the picture looks, it is not simple. Its rhomboids of shadow, the placement of the masses, the strong diagonals, the contrasting quality of surfaces all seem uncontrived and no doubt were: yet as the eye travels among them it becomes evident that these elements are indivisible. They cannot be separated or reduced.

The special schooling of those week-ends in Bucks County had been in fine volumes, in proportionate relationships, in the force of light as revealing these, and in the underlying order which belonged to the architecture and the crafts at hand. Sheeler feels that this was something explicit, which he describes not as "classic" but as "functional." "The shapes of the early barns of Bucks County—the barns perhaps even more than the houses—were determined by function; one sees that, feels it. The strong relationship between the parts produces one's final satisfaction. This may well be of importance to the artist who considers the working of the parts toward the consummation of the whole as of primary importance in a picture.

97

CHARLES SHEELER

"The artist may learn much from the contrasting surfaces employed in this architecture—wood, stone, plaster. Contrasting surfaces may contribute much to a picture, not merely to create interesting variations but for the actual design. A given texture, as of rough stone, may hold the attention by its rich complications and so give emphasis or depth which could not otherwise exist. A smooth texture may bring about a quickened tempo which may be essential to the whole. And what craftsmanship there is in some of those buildings, fine but almost unnoticeable! I would arrive at the picture which I hope eventually to paint through form that is architectural, whether the subject is buildings or flowers, set forth with the utmost clarity by means of a craftsmanship so adequate as to be unobtrusive."

Except for an occasional brief stay at Doylestown Sheeler was now separated from these major architectural sources. He was permanently settled in New York. His marriage to Katharine Shaffer had taken place in 1923. He had made a significant place for himself as photographer of works of art and was extending this to include portraiture, now that the De Zayas Gallery had closed. The general context remained what it had been a few years before except that the Arensbergs were gone. The Sheelers finally settled in Eighth Street, and theories were still abundantly vocal in that neighborhood; the French influence had not receded from the American arts. Brancusi came over for an exhibition of his own work and almost lived at the Sheelers' while this was in preparation, framing drawings, discussing plans. His interest in matters that concerned himself seems to have been almost undivided, but he was humble before his materials, and

could discourse by the hour on the attitude of submission essential for the artist, setting forth his conviction that a formal order exists within the wood, metal, or stone with which the sculptor works, and that it is this submerged order which he must set himself to discover. Brancusi had no doubt that his sculpture was classic, as indeed it is. When Sheeler photographed him standing in front of a mantel on which a photograph of some Greek sculpture had been placed, it was Brancusi who provided the caption, "Brancusi in front of his background." The Greek sculpture was part of an exhibition brought over by De Zayas, and represented another return to antique sources.

In other words theories as to classic art were still to the fore, with a sufficient number of examples to prove that it could have a manifold character. Sheeler had had not only the small Cézanne for a time but Walter Arensberg had also lent him one of Rousseau's great tropical pictures. Surely either was sufficient evidence of the primary classicism which had developed in French painting. But Sheeler's own direction was now strongly established, and the influence from such sources was indirect. At Doylestown he had begun to acquire early furniture and pottery of that region, not with a collector's interest—he has never been anything of an antiquarian—but for the pleasure they could give and because they were useful. They provided the strongest and most immediate context for his painting. Gradually some of them were to be included in his works as subjects, but the more particular influence which they exercised would seem to have been in the direction of craftsmanship and form. This was in part intangible, though one would say that the influence of form in these

99

respects went deep. "The way in which a chair or a fine table is planned is always interesting to me, it may be sculptural. The same quality belongs to the pottery of the Pennsylvania Germans, and that of the Shenandoah Valley. These pieces show, too, a fine sense of the eventual use to which they were to be put. One has a sense of purpose, or use, in these beautiful forms."

Craftsmanship is of course always a special matter; its mastery is over a particular medium, and the medium of paint is not that of glass or ceramics. Yet alliances and implications were offered by these objects, again in the handling of surfaces, in economies of material, in the use of dimensional line.

In his own medium Sheeler had long since shown himself the craftsman, from the time he had let the quivering brush-stroke go and had set out upon a long course of self-imposed training. The outcome was clear in the rendering of textures, the transparent color, the sensitive line that soon developed. In the new work which now followed Sheeler employed mainly the exacting medium of crayon or tempera with crayon, with an occasional departure into oil, working so far as possible without preliminary studies. "Timothy" alone could prove that he was a master of exquisite line. In the crayon and tempera "Stairway to Studio" (63) his linear command is extended to radically different and far more complicated forms, showing none the less truly because the ruled line was used in its geometrical patterns. Vibrancy in line that is ruled may be more difficult to sustain than in that which is drawn free hand, but its quality may be equally flowing and imaginative. In the quotation of Ingres' famous dictum, spoken in a rage

HOME SWEET HOME

101

AMERICANA

102

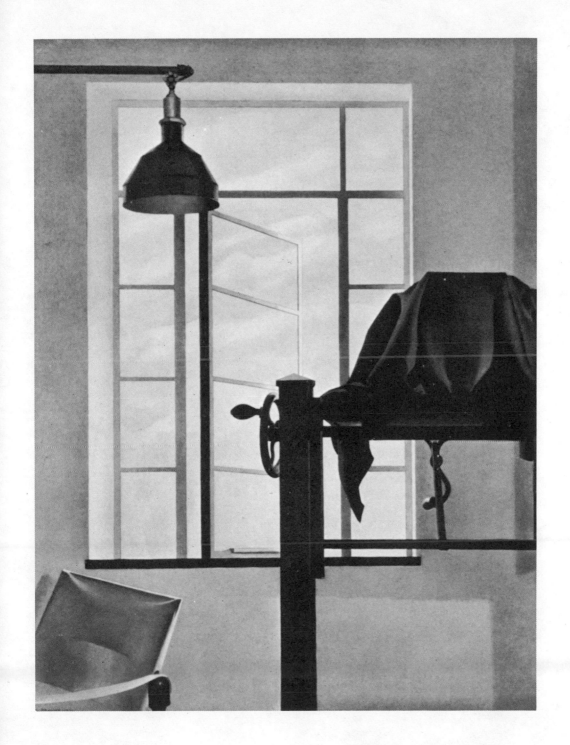

VIEW OF NEW YORK

103

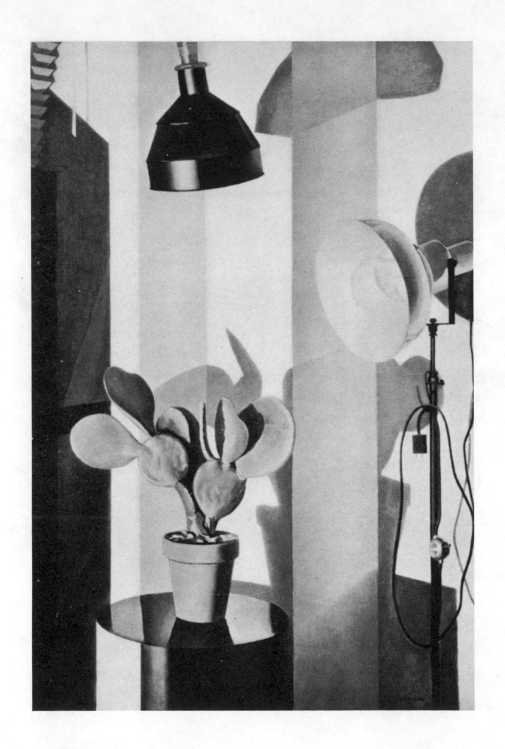

CACTUS

104

against a romantic artist—"La ligne, Monsieur, la ligne c'est la probité; c'est l'honneur même"—stress is usually laid upon the colder "probity" or honesty rather than the illumined "honor itself"—the quality which glows with imaginative intensity; yet it is "honor" which makes the climax of the sentence; it was this quality which Ingres revealed in the finest of his own drawings and which offers a criterion.

In the prism-like geometrical forms of "Stairway to Studio" note the fluency of the ascending lines on each side of the stairs—the one differing from the other in directing force, and contrast these two with the dark ascending line at the right, which has its own luminous quality. In turn compare this with the pairs of lines descending to the center of the picture from the top, with their shadings, tones, colors, intensities; these elements appear again in the gate, the railings, and the rhomboid by which the upper wall is defined. The empty spaces are full of light, life, volume. Since they are empty they might be expected to retreat into infinity, yet they remain palpable within the picture because of the tensile outlines which enclose them.

The word "plastic" has been associated with a loose handling of form, as if it meant only the rough shaping of malleable materials, left in the rough with immediate imprints and pressures upon them. Since Cézanne was the great modern master of the plastic and since, as he knew well, he had no command of sheer line ("the contour escapes me," he said) a tendency has developed to consider planes alone as revealing plastic values and to judge draughtsmanship by "big line" or large conjunctions of masses. This involves a narrow limitation. In point of fact the word "plastic" applies to anything that can be

shaped; the process need not be rough and ready, the form big and bounding; it may include the most delicate and precise modulations in dimensional form. It is the sense of design in masses—what the sense of the hand flowing into the material conveys—which may create plastic values in painting. It is not the movable or the malleable—the raw materials—which are the condition, but the formative, dimensional touch. This exists as clearly in "Stairway to Studio" as in the "Yachts" where the boats, water, and bellying sails are much more obviously "plastic." It is as clear in the diagonals of "Church Street" where one can hardly discover how dimension is conveyed as in "Chrysanthemums" (64) or "Still Life with White Teapot" (73) which recognizably use forms in the round.

Textures obviously conjure up the sense of touch and so may induce the plastic sense, yet a canvas may be as completely covered with renderings of texture as a piece of needlepoint and still not produce the illusion of dimension if free play in the realm of substantial form is not induced. Sheeler's reduction of the background and the squares upon which the vase stands to a smooth abstraction in "Chrysanthemums" is as important for plastic values within the whole picture as is the miraculously tactile rendering of the velvety shaggy flowers, because it leads to changes in those submerged movements of the hand which unconsciously accompany movements of the eye if the appeal of dimensional form is strong. Extreme elaboration of surface is placed against extreme simplicity. Here the artist has followed what he had learned from the employment of different surfaces in building.

In "Still Life with White Teapot" the complex pattern of shadows

and intervening light are played off against the substantial table, the objects on it, the definitive Persian band of the carpet. "The table," Sheeler says, "is the result of all the things that are happening around it. It stands out in space, not through the subterfuge of suppression of environment as in 'Chrysanthemums' but through the use of projected shadows."

The illusory and subtle complications of light and shadow in this picture are almost endless. The broad spearhead of light ascends from beneath the table and rises to the delicate geometry of light upon light above it with many tonal variations, and by another course the rectangle of light there will come up suddenly as if illumination had just been cast upon the wall. The final resting place for the eye is the group of objects on the table, finally of course the white teapot with its extraordinarily beautiful draughtsmanship. The band of Persian carpet below was an afterthought, Sheeler says, but one which was reached by the same process of achieving variations in texture which appears between the table and the shadows.

The severely continuous line of our older architecture and crafts may be seen transmuted here. The artist seems to have learned its possibilities once and for all in the early Doylestown abstractions, and now was using them with widely varying plastic force. Fine edges are used again with a geometric definition in "Staircase, Doylestown" (74) where the powerful twist of the squarely spiral staircase, the fan-like twist of the overhead beams, the whole strong counterpoint of geometrical line and volume—which is broken only by the irregular forms in the right foreground—are contained within purely linear

definitions. They seem simple yet they are not simple, just as the forms seem repetitive but never fully are. In certain crucial passages they are eliminated, as in the three divisions of the staircase wall, which make a progression through differences in form and tonal contrasts, receding upward yet returning to the middle passage, then dropping to the room below because of a relationship in values. Then the eye becomes involved again with the broad firm risers and treads of the stairs. "Two things are going on at the same time in the picture," Sheeler says, "irrelevant to each other but relevant to the whole, one in the room downstairs, one leading to the room upstairs. I meant it to be a study in movement and balances." The color has a muted brilliance, ranging from mustard yellow to burnt sienna, from the black of the table top and its vermilion legs to sharp pink at the head of the stairs, with all these colors played down rather than up.

In "Provincetown Church" (75) linear edges enhance the purity of the architectural forms portrayed, making an expressive contrast between these and the opulence of the horse-chestnut trees, the mounds of the shrubs, the sonorous loose shadows on the grass. Yet these definitions, though characteristic, were not by any means a formula. In "Offices," an oil, which is strongly abstract, they are used only in part. Light seems to have reduced the effect of pure line; its formal patterns are more loosely cast. The crayon bearing the same name has a similar quality. A lithograph, made a few years later, using a similar subject, "Delmonico's," with its soaring diagonals shows revolutionary change away from the downward concentration

of "Church Street," and where darkness makes the undertone of the earlier picture, this is all rising light, modulations of light, with ledges, the lifted forms of the buildings, the small particular definitions of the serried windows revealed by stresses in brilliant light or in tonal variations of shadow. By a typical departure in contrasts of subject Sheeler also made a group of drawings of nudes at this time in crayon, which are all design, revealed by the use of shadow rather than direct definition.

"Light is the great designer," Sheeler says; but his axiom belongs to a special mode of perception. Among the French impressionists light served to disintegrate design. With Sheeler light becomes a palpable medium through which form is apprehended to the full, through variations in its quality, through contrasting shadow, through modulations of tone within shadow. In none of his work may shadows be taken for granted as incvitable accidents. They have great intrinsic beauty as have the simple passages—as of a wall—where light is merely playing: and they invariably have a major structural place—one may rightly say—an architectural place. A full perception of the use of shadow in his art may lead to an understanding of its most fundamental qualities, bringing the spectator back finally to the constant use of light itself as a dimensional force. It may be used abstractly or realistically; the outcome is a possession for which his work has become notable—values, those relationships of light and shade by which substantial form is revealed. "I never get over the differences between a landscape under clouds with every form receding into a common mass and the same landscape when light falls upon it, bring-

ing out form after form." If light is not perhaps the final transcendent force, if in fact design lies in the eye of the artist, the perception suggests a growing principle.

Design seems a latent order which he has revealed rather than something that has been superimposed. Occasionally what he has called "subterfuge" was stronger at this time than he would now believe to be as valid; he still sometimes alters natural shadows in order to enhance design; he was using arbitrary color then and still uses it: but the continuous intention of his art has been to permit the intrinsic forces in a picture to have their way within the boundaries of a natural, not an artificial relationship. Much of his special skill has lain in the ability to accomplish this sometimes difficult end, without arbitrary changes. It is true that he still was using occasional "arrangements" in black or colored crayons whose major concern is indicated by their titles: "Suspended Forms," "Demarcation of Forms," "Forms in Space." But his conviction had grown against the difficult or the esoteric in art, and these studies were diminishing in number. After his first phase of pure esthetics he had come to believe that "it is the function of a picture to persuade us to enter it. There are pictures which completely shut us out, as if we were looking over somebody's shoulder as they read. It seems to me that they would show us the book if they wanted us to know about it."

But not to show us with emphatic display, even when the accomplishment was most difficult: this had become one of Sheeler's most positive principles, indicated clearly by his strong tendency to conceal the means of expression. In "Still Life with White Teapot" the

way in which the patterns of light in the background have been cre-
ated are almost undiscoverable. The realization of the teapot itself, the
quality of the glaze, the particular thinness of the porcelain, the deli-
cate roundness of the body are conveyed only by a few formal
shadows, by modulations of tone which merge—no one can tell where
—into pure white. In "Chrysanthemums" with its infinitesimally close
rendering of texture and color—color in texture—the medium can
hardly be separated from the subject; fiber by fiber the petals are
there, but the intricate means has been submerged.

As in the years when, with Schamberg, he had departed from the
teachings of Chase, Sheeler's concept of art was diverging radically
from a major movement of the time, one which still largely governs
popular thought about art. Indeed Chase's canon was being continued
by a far less pretentious teacher, of much greater human warmth and
understanding, one of the "Eight," Robert Henri, who had split from
the Chase contingent at an early date though by a narrow margin so
far as art is concerned, not at all as to essential direction. Henri, like
Chase, was all for the explicit assertion of personality in art; individu-
alism was something which must speak with pronounced force. The
artist was self-exalted after the manner of Whitman, whose name was
often on his lips. "It seems to me that before a man tries to express
anything to the world he must recognize in himself an individual, a
new one, very distinct from others." This was romanticism pure and
simple, which has always insisted that the individual was strange,
unique, portentous, and unmatched. Modest enough in his own char-
acter, Henri followed the idea through with extreme logic. Not only

111

was the individual unique but the moment was; he too insisted upon the illusive moment. The artist "must be cool and he must calculate, but his work must be quick. . . . It is as though he were in pursuit of something more real which he knows but has not yet fully realized, which appears, permits a thrilling appreciation, and is gone in an instant."

Eager to get on to the subject at its special "moment," Henri tended to push aside the problem of backgrounds and spoke of them as "unified by obscurity." He could not for the life of him consider a painting as a possible balanced whole whose every area might be significant. Occasionally he paid tribute to design—"The good painting is a remarkable feat of organization"—but this was nullified by the example of his own work and by other arguments in his teaching. "Count on big line to express your ideas!" he would cry. He considered that the old masters had little to say to the modern artist mainly because of their concern with values, with detail. "With the great old master the hand becomes a symbol. He made the symbol by making a hand significant, monumental, but of such material definiteness that it is photographically perfect. The hand by the true modern will not lend itself so readily to black and white reproduction"—because of the absence of values. In other words the artist should not become too profoundly involved in his subject; he should seek his own individual vision: "I want to express my own personality," as myriad followers of the idea in art and life have freely said. At the worst this leads to what may be called "whoosh" in art, an intensive sweep around a few focal points, broad chiaroscuros again, and—

almost inevitably—the dark palette. Henri explicitly suggested that white be left out of the gamut employed by his students, and light, which permits a subject to be revealed in full character, was not primary for the simple reason that the subject was not truly primary. The artist in this mode considered himself as primary. His subject was freely and loosely and naturalistically rendered with that consideration in view.

Naturalism was having its long day in our literature from Zola by way of Dreiser, and in our art through many figures, Henri among them, and its implications as to the unorderly, as to swift impressionism, as to illusion versus permanences were still highly popular. Sheeler had taken a direction which was diametrically opposite in every respect, which meant a full dedication to the subject and a search for the underlying order to which it belonged. The two philosophies, the two groups of purposes are radically at variance. The two forms of art make different demands upon the audience. Bravura—an assertive individualism—is absent from Sheeler's work. To look for it is to miss its intention. The craftsmanship to which he had given himself may be taken as a clew to its character. The history of craftsmanship in our painting tells much of the story.

In the first phases of our art history, craftsmanship was sustained as an inheritance from those periods in Europe when the artist was first of all a journeyman. Whatever else he might become he possessed certain skills. American painting of the eighteenth and early nineteenth centuries is full of traces of this inheritance, appearing as richly in anonymous work as in that of well-known artists. Some of the rudest

of our primitive portraits show a revelation of character and a use of the medium which any contemporary artist might envy, with effects created by an exquisite application of paint, with the greatest economy of means. Design inhered in this work almost consistently, as in all the major sequences of our early painting. But these traditions were broken, and a dozen reasons may be found to explain the circumstance, not only in the advent of the machine, or those conditions in pioneer life which often worked against a slow and rich local development of painting.

Not least of these influences was the force of a broad prevailing idea, that of a strongly formulated and assertive individualism. As has already been suggested, craftsmanship in the past was kept alive by "schools," by their close contagions, their continuities, their lively concerted movements. Fine craftsmanship has been mainly a social affair, deriving from the accomplishment of many workers. It is not concerned with individualistic assertions but with the object at hand: this must be "right." Devotion or affection are the words most often coupled with it. Though it does not create classic art, it is at the base of that deeply formal art which we call classic.

Craftsmanship has sometimes been spoken of as an elaboration of form, particularly during the artificial revival of the handicrafts which has developed within this generation, but in its essence it is nothing of the kind. In its major periods, fine craftsmanship has been directed toward a strict, even a spare revelation of the object. Technique on the other hand—which has been emphasized in modern art—is elaborated skill. Through technique, as Sheeler discovered in

Chase's teaching, attention is directed to this exterior shell, or to the individual who brilliantly contrives it.

The schools have gone, and the broader continuities in American painting are still, as we have seen, difficult to discover. The tradition for craftsmanship has been ruinously broken. It no longer speaks a familiar language, nor does it arouse that immediate, sensuous response which naturally belongs to it. Sheeler had found a major and enduring source of craftsmanship in architecture and the crafts, and had turned this to his own ends: and he was not alone in this concern or in the preoccupation with design in these years. Demuth and Dickinson, with whom he was now often exhibited, were among those occupied by the same factors in painting. But Demuth, who had also been a pupil at the Pennsylvania Academy, and was a genuine craftsman, remained strongly under French influence, and tended, with his often ingenious and charming fancy, toward external pattern. Neither Demuth nor Dickinson had struck back to our primary sources in dimensional form as had Sheeler.

The broad movement of the time in art seemed to be that which Henri represented, which he did so much to promote. It was lively, honest, readily understandable. Its individualistic stresses gave it a quick entry. Thus, according to a formula which even then was in vogue, the American artist who chose a more difficult mode should have been experiencing a profound isolation. He should have joined the group known, too sympathetically, as "lonely Americans." He did not, perhaps because responsiveness to art in this country is a more fundamental matter than some of our critics would have us suppose.

CHARLES SHEELER

In any event, Sheeler's work was well shown, admired, and sufficiently understood in these years, and the individual drawings or paintings passed, almost without exception, out of his hands. This may have come about for the simple reason that he was working in the American grain, not against it.

5

FROM THE TIME he settled permanently in New York, Sheeler's art had been confined to the narrow space of week-ends and occasional evenings. His major occupation after the De Zayas Gallery closed in 1923 was photography, as a means of earning a living. First occupied with photographing Chinese works, Negro sculpture and other primitive art, he soon made an extension into photography for advertising, which in these years was becoming an immense industry.

A major phase meant work on *Vogue* with Steichen. "I had seen a portrait of Steichen years before in one of the annual exhibitions at the Academy in Philadelphia but since it was not by Greco it did not inform me of the reality I was later to find in the man. Tall, lanky, with a head that may be described as intentional, a manner of speech that is brusque at times and always devoid of ornamentation, he keeps his esthetic proclivities well underground. Coming upon him in a railroad station one would realize readily that he was not one of those who were just waiting for a train. When he discusses either of his two major interests, photography or plant breeding, it is time to realize that one is near the source on that subject." The two became friends among the temperaments occasionally thrown by actresses posing as fashion models, in the dramatic rush which always exists

with looming deadlines—friends the more because Steichen had also been a painter and because each regarded photography as significant for its own sake.

From the time of his exhibition at the Modern Gallery in 1918, Sheeler's photography had been remarked for its unsentimentalized renderings, which were not always understood by those who preferred their realities veiled or enshrouded. As might be expected from the direction which his painting has taken he has consistently stood for the simplest technical means. Believing that ready duplication of a print is characteristic of the medium, he has preferred the silver rather than the platinum base for the greater facility afforded, and avoids the various elaborate processes employed by some of the pictorialists which involve extensive manipulation to obtain the final result. He insists that photography should not be a hybrid, taking on the aspects of painting, becoming "neither fish nor fowl, photography nor art." He uses "straight" photography, the undisturbed record by the camera eye upon the sensitized emulsion and the conversion from negative to positive by the most direct methods.

"When one goes back to our early photography whose mechanics was extremely simple and from our modern point of view often crude, it's easy to see that the present immense elaboration of means isn't very important. One wonders whether there is such a thing as progress, for some of this early work has never been surpassed."

Sheeler uses and indeed helped to create for present-day photographers one of their primary canons, no retouching, which means full acceptance of the disciplines of the medium. "Zoop for the moment!"

is Steichen's way of putting the momentary intensity required. "It's like throwing out a lifeline to a drowning man. Either he catches it or he doesn't catch it. He doesn't partly catch it." The photographer deals with time almost as a primary force, as a constituent in his work, time in exposure, time in development, time as molding his subject. Time becomes almost palpable, its use an instinct. Sheeler has followed this logic to its many completions instead of attempting to make photography approach painting; indeed he consistently believes that the approach of one to the other is impossible.

"Photography is nature seen from the eyes outward, painting from the eyes inward. No matter how objective a painter's work may seem to be, he draws upon a store of images upon which his mind has worked. Photography records inalterably the single image, while painting records a plurality of images willfully directed by the artist. In photography the lapse of time consumed between the selection of a subject and the final evidence of accomplishment is negligible. This has to do with the mechanics of the medium. The time elapsing between the conception of the painting and the final fulfillment is necessarily immeasurably longer. This has to do with the mechanics of painting. It is inevitable that the eye of the artist should see not one but a succession of images.

"Perhaps it would be well to call attention to the difference in operation between the lens and the eye, in viewing a subject. With the lens, obviously the point of observation is fixed, and everything within the plane of focus is in equal definition at the same time, but the eye is roving, and includes at one time only a very small area that

is sharply defined. Moving on, it performs the same function within another area, so that the total vision of a landscape, for instance, is really a mosaic of small fragments separately seen, which become united in our memory. This composite image creates the illusion that we have seen at one time everything within the landscape sharply defined, from the rocks at our feet to the distant blue hills, but we have not.

"The lens, because of its greater speed in registering the image, has added to our knowledge much information of which we would have remained ignorant if we were dependent upon the eye. Notable in this respect during recent years has been that phase of photography which is able to record the swiftness of movements taking place on earth, sea, and in the air. With the additional facilities provided by fast lenses which make possible these records of speed, we now have visual records of the most casual glimpses of people under transitory conditions of light and in changing circumstances which previously could not be achieved—which the eye alone cannot see.

"Because of the differences between the two processes it would seem that the encroachment of one upon the territory of the other is impossible. I have come to value photography more and more for those things which it alone can accomplish rather than to discredit it for the things which can only be achieved through another medium. In painting I have had a continued interest in natural forms and have sought the best use of them for the enhancement of design. In photography I have striven to enhance my technical equipment for the best statement of the immediate facts. I have never seen in any painting the fleeting

glimpse of a person's character that I have seen depicted in some pho-
tographs, nor have I seen in any photograph the fully rounded summa-
tion of character that Rembrandt or Greco portrays.

"Photography is only visual, thank God! The lens is an unpsycho-
logical piece of glass whether formulated by Zeiss or Bausch and
Lomb or whomever."

This is not to deny photography its place as an art within its own
limitations and potentialities—if that ancient question still persists, and
it is far from saying that the camera renders merely the immediate
image in black and white or that its use is entirely impersonal. In writ-
ing of some of Stieglitz's earlier photographs Sheeler found among the
sky forms "an area of unmistakable, cold hard blue expressed with
superb intensity," suggesting that color need not be read into the
photograph but may be objectively revealed there for the eye that
knows in what forms, in what light, this quality of color appears in
nature. Fine photography is of course full of the suggestion of color,
and even individual prints from the same negative may show sensitive
differences. Sheeler feels that these differences are still insufficiently
realized and enjoyed, in spite of the great current vogue of the camera.
"Each print has an intrinsic life of its own, and there should be the
same sort of discrimination between fine photographic prints as be-
tween different Rembrandt etchings. Work like that of Steichen or
Edward Weston should be collected in portfolios with the same sort
of zest that etchings are collected, or lithographs. It's a pity this is not
happening in a broad way, for much of the significant work of the
camera of our time may go out, say in a hundred years, because some

121

of the finest examples are considered only of transitory, journalistic interest and because the medium is so perishable."

In his insistence that the camera is first and foremost a fact-finder Sheeler is far from eliminating the element of design: on the contrary design is essential in his photography. The final impasse of the purely factual school is reached by those who do not believe in cropping: yet the lens itself necessarily imposes arbitrary limitations of space and proportion, so that it seems mystical rather than realistic to insist that these limitations should be maintained precisely in the final prints, as if the true truth were always caught by the special instrument at hand. Sheeler uses cropping decisively, skillfully for the enhancement of design or fact; as one would expect from his painting the element of design is basic though not insistent in his photographs. The broad direction of his painting was established before he had used the camera; his photography has inevitably gained from his development as a painter, in choices of theme, in structural elements, in the rendering of textures and surfaces. Structure as well as surfaces were unfailingly revealed in the simple, early, very beautiful "Side of a White Barn." With no loss in the lively glimpse of character Sheeler could include in a portrait of a woman every touch in costume, the sheen of feathers on a hat, the stitched embroidery of the cloak and dress, the weaves of cloth, where other portraitists in these years were likely to use a soft focus and a few generalities, with details suggested, not transmitted.

What he has consistently avoided is that mode of overdramatization which has tended to dominate photography since the advent of

the motion picture. "I try to present the subject as far as possible without imposing anything—to give it on its own terms." Steichen says that Sheeler never intrudes himself in a picture, and goes on to compare "Side of a White Barn" by Sheeler with a photograph of a barn by Stieglitz—not the same barn—as illustrating the difference between the objective and the subjective approach. An interesting wrangle might follow upon a discussion of these elusive elements. Sheeler calls Steichen's famous portrait of the elder Morgan "a very subjective photograph." There can be no doubt as to Sheeler's habit of detachment; he is concerned only with his theme, yet the result may have strong associative values which mean a turn toward subjective values. His photograph of a stairwell at Williamsburg (192) may seem to some observers an almost wholly subjective picture, even a symbolic representation of a phase of mind—abstract, severe, contemplative— particularly if it is set alongside one of the very expressive free series of windy cloud and sky forms of his other more recent work, which suggests another emotional content altogether. Such effects may be created partly by the force of contrast. If a subjective content exists in the "Stairwell" it is because the view which could reveal this has been subtly chosen, the record exquisitely made from the time the camera was focused upon the subject until the print was mounted.

In 1927, as a commission, Sheeler went to Detroit to photograph the Ford plant at River Rouge and came away with another genuinely rich series, wider in scope than any he had hitherto attempted, different in subject, wholly different in the exactions imposed. The final photographs were in no sense the outcome of a first rapid enthusiasm

123

or of fortunate shots, but of close study, though the enthusiasm was sustained. He spent six weeks at the plant, clambering about the wharves and factory bridges, moving from one point of vantage to another for angles of view, taking no photographs until the character of these structures had become a possession for the eye, until he had approximated that saturation in form which he might have experienced more casually over a longer period.

It is hard to believe that a little more than ten years ago the industrial subject was considered a striking novelty. It was widely recognized at the time that Sheeler's Ford series had broken into new territory. Yet the photographs which ensued--some thirty-two in all—did not depend for their force upon the fact that they offered an innovation. They are as powerful today as they were then, holding their own through integrity, through complete concentrations and inclusions of form. Sheeler might easily have exploited the subject; instead, he penetrated and revealed it. Bridges, smokestacks, coke ovens, blast furnaces, the steel-cutters, slag-buggies, dynamos, the many-windowed sides of buildings, the great masses of the plant are so brought into conjunction as to reveal inherent sequences in fundamental structure. All these photographs have a striking clarity, not only because nothing seems interposed between the observer and the scene but because clarity seems of the substance of the subject as the photographer saw it, in the clear-cut solid outlines of buildings, in iron bridges against the sky, the open spaces let into more than one of the pictures to reveal an inherent amplitude. Detail appears in many minor forms, in surfaces, character of walls, in small moving figures of men over the bridges or

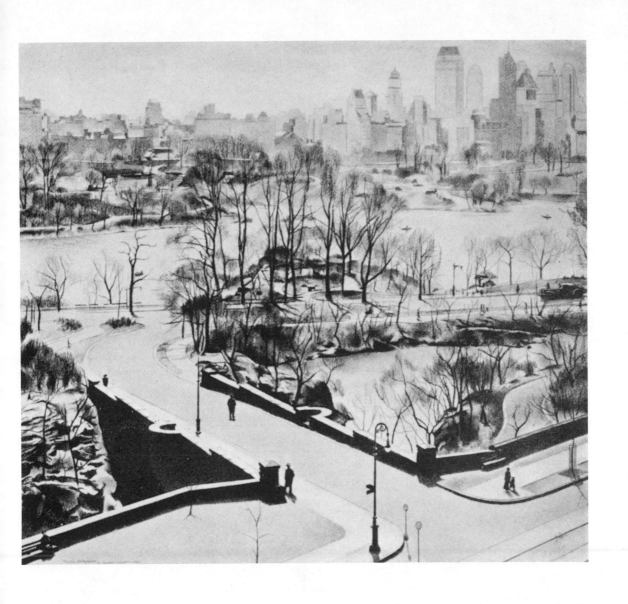

VIEW OF CENTRAL PARK

125

PORTRAIT

126

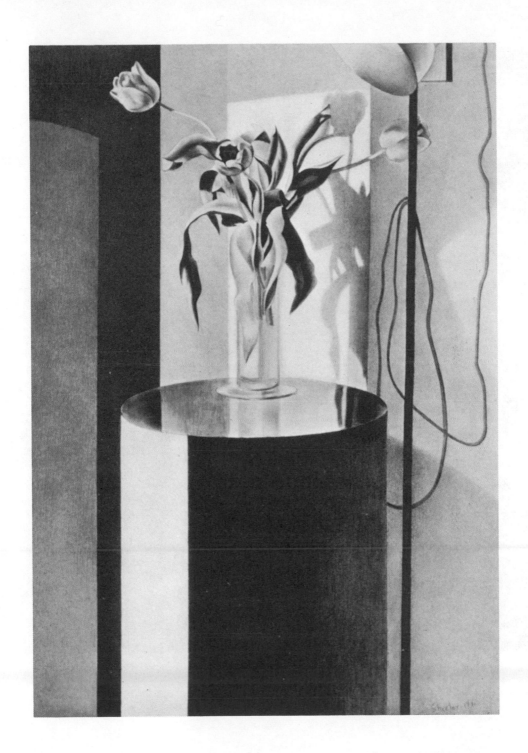

TULIPS

127

FELINE FELICITY

128

along the platforms: but nothing is elaborated, crowded, or forced: here is an epitome of mechanics with magnitude and power.

These photographs were widely published in this country and in many countries abroad as distant as Japan and Russia; they resulted in a semi-official invitation to visit Russia and make a similar sequence there portraying the new industrial developments. This Sheeler declined. "It would have meant a break in continuity. There is as much to photograph here if we can see it." Yet he has not applied this theory with doctrinaire precision; in fact he departed from it a year or two later, though apparently not by intention or forethought, in another series of photographs made during a trip abroad, of Chartres cathedral.

Chartres became "one of the outstanding experiences of a lifetime. . . . The approach to the town, with the cathedral seen towering over it from its elevation—the increasing detail upon drawing near with an increasing emotional response—arrival at the portal—then the moment of entering—a sense of peace—the brief illusion that by accepting the religion that brought it into being this sense of union could be perpetuated—the realization that this was a moment not to be made captive.

"Out into the sunshine again—walking and looking: but no photographs. Something of the ego of the artist must be restored before the illusion of equality could be re-established, and work could become possible.

"By a carefully selected series of sections of Chartres I hoped to produce a more comprehensive presentation than would be possible in

129

any one photograph showing the cathedral in its entirety. Fourteen photographs resulted, and one day I hope to return for the hundreds more that are yet to be made.

"Chartres is the flower of a time, having its roots in the deeper emotions of a people who were sharply focused upon religion and who sought the relief of outward expression. Religion was a great mass consciousness, and by the projection of the cathedral the welcome opportunity was given them. Every age manifests itself by some external evidence. In a period such as ours when only a comparatively few individuals seem to be given to religion, some form other than the Gothic cathedral must be found. Industry concerns the greatest numbers—it may be true, as has been said, that our factories are our substitute for religious expression.

"Even though I have so profound an admiration for the beauty of Chartres, I realize strongly that it belongs to a culture, a tradition, and a people of which I am not a part. I revere this supreme expression without having derived from the source which brought it into being. It seems to be a persistent necessity for me to feel a sense of derivation from the country in which I live and work."

The Chartres series represents another of Sheeler's outstanding achievements in photography. Though, as he says, he determined to record sections rather than the whole, these have a generic, monumental force which transcends their intentionally limited revelation. Serried ranks of buttresses, arches, the multiple moldings which comprise doorways are revealed with a primary intensity and power. Distinguished as the series is for its technical rendering of surfaces and of

the basic sense of stone, it is finally notable for its diametric inclusions. It concentrates the whole within the parts (191).

The series of photographic studies has obviously been a matter of major interest for Sheeler—not merely the sequence of views but the closely united study of a single subject. In a fresh way the series, as he has developed it, means a consideration of "polyphonic form"— form seen in many modes. This has extended among subjects which might not be considered as lending themselves to the series, such as skies. "I collect skies." Such inclusions have not of course meant any sort of avoidance of single studies. A photograph of a small white-plastered stone cottage in Maryland shows the inclusion of a favorite theme, an example of our provincial architecture, in a fine record made by the swift seizure of a fine moment as light revealed every phase of its structure. A landscape in the Blue Ridge mountains has exceptional beauty as to choice of theme, and also represents one of this photographer's great technical achievements. The richness of the sky forms, the contours of the distant mountain ranges, the material details of the open road are all accounted for closely, firmly, yet delicately where delicacy is required, all without artificial manipulation of the means, by straight photography.

The mechanics of photography offers a great interest to Sheeler— interest which extends on his part to finely adjusted mechanics of any kind, in watches, in minor gadgets. "These mechanics have esthetic values of their own. I believe that the term artist should have a wider application than is implied by reference to the fine arts. An artist should be able to turn his hand to other materials. Perhaps it's because

131

we so seldom do this that the artist feels, as a good many people have said, out of the picture today. Maybe we aren't closely enough related to the active life of our time. At any rate I have had a try in that direction, though it could hardly be called more than an excursion."

The excursion meant making designs for textiles, mainly by photography, using natural objects in repetitive patterns, leaves or berries, sprays of ground pine, occasionally marbles or small boxes. It also included designs for glass and silver. The flat pieces in silver are simple, severe, following the low, horizontal forms of some of the older English or Irish silver but with more rigorous forms, without ornamentation. They lack the assertiveness of much so-called modernistic design; they are simply and directly usable. The employment of rectilinear forms for the spouts, handles, lids, and bases of the tea and coffee pots is intrinsically interesting; their lines are bold; modifications have been made from the usual placement of spouts and handles in the interests of effective use. One of the tumblers, in Steuben glass, departs only a little from the typical severe cylinder but enough to give it distinction, and three sharply shelving edges toward the bottom make it firm for the grasp besides having great linear beauty. All these pieces have an individual stamp. A manufacturer who is also an art collector said on seeing some of them that he would have known they were by Sheeler as definitely as if they had been signed.

A small organization, resembling a guild, was hopefully formed by a few artists and photographers, but though similar talents are widely engaged for advertising, the time does not seem to have arrived when they are coveted for the creation of the commercial objects adver-

tised. Unexpected difficulties appeared, not least those involved in recognition of the quality of the work. Manufacturers often seemed unable to discriminate between simple excellence, which had its severities, and the flaunting "modernistic." Problems arose as to patents or registration. "One artist designed a beautiful plaid—a plaid to end all plaids. There was nothing like it. But our laws on such points seem rather general, and it was found impossible to register this plaid, because another, quite dissimilar had already been registered. Some of the designs for textiles which were used in manufacture were promptly copied in cheaper materials. I understand that groups have now been formed for the protection of their members in such matters but even so there seem to be difficulties. I had to sign off because of the time involved, and the experiment came to an end.

"I expect never to lose the kind of interest that went into those things. It has had much to do with my growing enthusiasm for the Shaker crafts and architecture.

"The Shaker communities, in the period of their greatest creative activity, have given us abundant evidence of their profound understanding of utilitarian design in their architecture and crafts. They understood and convincingly demonstrated that rightness of proportion in a house or a table, with regard for efficiency in use, made embellishment superfluous. Ornament is often applied to forms to conceal uncertainty—and this applies to painting too. The Shakers would seem almost to have had a mathematical basis for their crafts, so knowingly and with such exactitude were their designs planned and realized. With knowledge of the tenets of their religion we are led to

believe that beauty aside from utility was not desired. Their furniture and textiles and their tools of iron or wood represented conspicuous necessities, and so well were their plans for communal life formulated and practiced that they all but achieved a complete independence in agriculture and industry.

"They recognized no justifiable difference to be made in the quality of workmanship for any object, no gradations in the importance of the task. All must be done equally well. Whether it was the laying of a stone floor in the cellar, the making of closet doors in the attic, or the building of a meetinghouse, the work required nothing less than all the skill of the workman.

"It is interesting to note in some of their cabinet work the anticipation, by a hundred years or more, of the tendencies of some of our contemporary designers toward economy and what we call the functional in design. A combination of purposes was served within one unit in pieces of ordinary utility, as in a tall cabinet that has closet space with doors at the top and a number of drawers running the full width with smaller closets below made for special uses. The number of such adaptations and variations which the Shakers could create seemed almost infinite. One such tall cabinet has small drawers running all the way up to the top for apothecaries' remedies, another seems to have been made for seeds and for the labels and boxes which went with them—they sold their seeds, as they sold some of their crafts, to the 'world.'

"It was also their custom to combine agreeably several kinds of wood in one piece of furniture, not for ornament but because one or

another wood seemed to suit a particular place or function best. They could understand wood—that is, they knew well the medium in which they worked. They seemed to believe in a very simple way that there was a special life in material things. Read Hepworth Dixon's account of his talk with Elder Frederick Evans about the planting of an orchard and see if you know anything more beautiful. 'A tree has its wants and wishes,' Elder Frederick said, 'and a man should study them as a teacher watches a child, to see what he can do. If you love the plant, and take heed of what it likes, you will be well repaid by it. I don't know if a tree comes to know you. I think it may.' And he goes on to explain that the Shakers first got the very best cuttings within their reach, then created proper drainage, laid down tiles and rubble, filled in with manure and mold, set the trees, and protected them. They gave this kind of care to everything they did.

"According to Dixon the difference between the Shakers and others was that the others seemed mainly to be looking for returns while the Shakers were striving to do the particular thing as well as it could be done.

"Seeing the Shaker meetinghouse at New Lebanon recently showed the difference in emotional response to the thing which is of one's own lineage from that which is not. It has a final assurance and is sufficient of itself to make one rejoice in having derived from the soil that brought it into being.

"The building comprises a large and a small member, having the same axis, with a low arched roof over each. The larger member encloses the meeting hall, a room eighty by sixty-five feet, free of

135

the usual obstructions of supporting columns. The arched ceiling is maintained in place by structural timbers between ceiling and roof. Rows of banked benches of simple and beautiful craftsmanship run the length of the longer walls, and above them are tall windows of fine proportions, placed at intervals in the wall spaces. Large double doors in these walls admitted those not of the faith. The entrance for the Shakers was through three doors at the end, opening from the smaller member of the building, the door on the left admitting men, the center the clergy, the one on the right admitting women. The smaller member of the building formed a cloak-room, with stairs leading to living accommodations for the ministry. The balance of vast space with that of more intimate proportions was achieved by the greatest economy of means.

"No embellishment meets the eye. Beauty of line and proportion through excellence of craftsmanship make the absence of ornament in no way an omission. The sense of light and spaciousness received upon entering the hall is indicative of similar spiritual qualities of the Shakers. Instinctively one takes a deep breath, as in the midst of some moving and exalted association with nature. There were no dark corners in those lives. Their religion thrived on light rather than the envelopment of a dark mystery—with the Shakers all was light, in their crafts and equally with their architecture.

"I don't like these things because they are old but in spite of it. I'd like them still better if they were made yesterday because then they would afford proof that the same kind of creative power is continuing."

136

INTERIOR WITH STOVE

137

THE OPEN DOOR

138

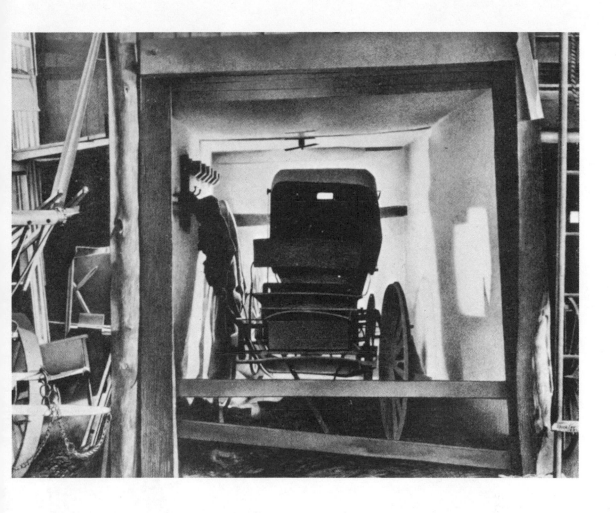

INTERIOR, BUCKS COUNTY BARN

139

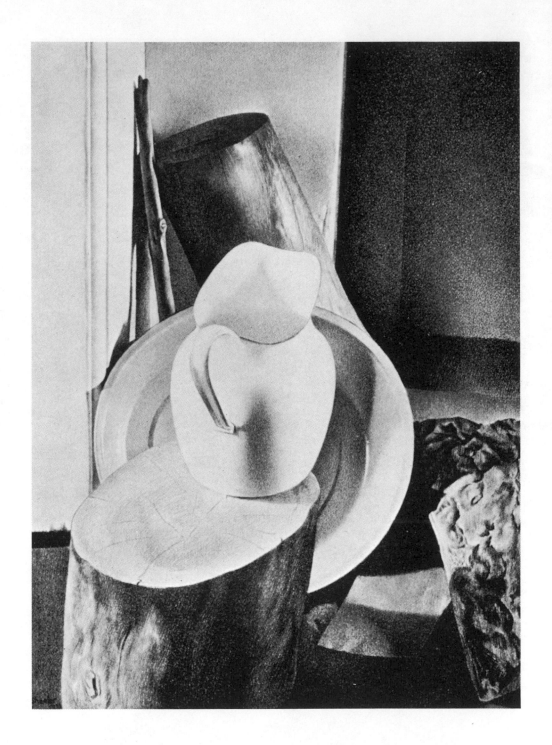

OF DOMESTIC UTILITY

140

Shaker architecture and crafts were taking an important place in Sheeler's considerations as an artist, similar to that of the buildings and crafts of Bucks County. They belong to the same general order of communal expression, even though the Shakers were more closely united than any of the groups of settlers in Pennsylvania who gave their practical arts distinctive forms. Creating some of the earliest of the American communes, they continued in growing strength from the latter part of the eighteenth century well through the nineteenth, with settlements established in half a dozen places in New England and New York and others in the Ohio Valley: thus the spread of their influence, particularly since they sold their crafts to "the world," was not inconsiderable. They represent an integral part of our tradition.

No theory of esthetic origins quite accounts for their crafts. Severe, tending to height, imperial even yet adapted to humble uses, their household and shop pieces seem to have been created out of their own way of life without reference to antecedents. Occasionally their furniture or textiles employed forms in use elsewhere, particularly in New England, but even these were usually given a distinctive stamp, and their typical chests and cupboards, tables and chairs were essentially their own. They are unmistakably Shaker. One of their sayings, "Every force has its form," seems to have proved itself in these wholly utilitarian objects.

Several years after he first came to know them well, around 1927, Shaker pieces began to appear in Sheeler's paintings: the favorite long table and benches are used, with Shaker boxes and a little music stand: it is characteristic of Sheeler's approaches that they did not ap-

pear immediately. They were not primarily subjects. Like the Bucks County crafts they represented an experience in form which had to be assimilated before they could find a place in his work. As an influence they happened to coincide with that of wholly different forms, those concentrated in the Ford plant at River Rouge. He came to know them at about the same time he went abroad for a long trip, which meant Chartres and also a thorough exploration of the galleries, during which he saw again not only paintings with which he had become familiar during the trip with Schamberg but those he had seen more briefly earlier as a student under Chase. Greco, Holbein, Memling, the Van Eycks, Rembrandt, the Master of Avignon, but particularly the northern artists of the later phases of medievalism, became subjects of special study.

The many problems of realism had begun to occupy Sheeler more fully than heretofore, and it would be easy to attribute this to his very specific study of works in the European galleries. As a matter of fact the turn had been taken before the trip was made, first of all in "Interior" (Whitney), which makes a full use of environment. This was painted before he went out to the Ford plant and is much higher in color key than most of his painting, with background panels of warm yellow; the picture centers upon the cool brilliant green and red apples on the table. The fresh and graceful "Spring Interior" (76), which was done immediately after his return from Detroit, again fully uses environment, and confirmed the new direction. This picture was painted rapidly, without preliminary study. For nearly two years after it was completed Sheeler did not paint at all. He had now moved to

the country, which meant South Salem. With the continued dramatic stress of commercial photography he often lacked even the narrow spaces of week-ends for painting, but the pause seems to have had less to do with the question of spare time, of which he had never had much, than with new considerations as to the form which his art was to take.

Then came "Upper Deck" (81) which was painted before the trip abroad, and meant a complete change in subject, intention, handling. He says when he finished he felt, "This is what I have been getting ready for. I had come to feel that a picture could have incorporated in it the structural design implied in abstraction and be presented in a wholly realistic manner."

Material representation in this picture is almost tangible; its forms have the precision and solidity which an engineer turned painter might give them, and they are not single but multiform; this is a crowded section of an upper deck though it does not seem so. In color "Upper Deck" is pitched high, with funnels, shafts, dynamos, in strong whites with bluish shadows and a warm undertone; the openings of the funnels are black—"And I meant black, like pistol shots." A thunderstorm might be rising late in the day; the sky is faintly pinkish. The light is still brilliant, the stretched cables are black, the cast shadows clear. The picture has been called "ascetic as a primitive in its feeling, in its drawing, in its severe scheme of whites and grays," yet buoyancy transcends severity; the whole has the effect of height, space, air that belongs to its subject, and few primitives have been at the same time so simple and so complex.

Design is the primary force in achieving this simplicity, that three-dimensional design with which the artist had long been occupied, now freshly evolved. Formal relationships have been perceived and rendered in terms which, with all their immediacy, are often highly abstract. Abstraction is present in resolutions of form, in the sometimes almost unmodulated uses of white and black, in the use of pure line. Plane after plane, surface after surface has been reduced to its simplest elements in form and color. The balances throughout are clear, vibrant. None of this was wholly new in Sheeler's work: he had combined close representation with abstraction before, breadth and balance with detail: but the scope was new, and the accent upon close realization was so pronounced that the use of the alternate force of abstraction could pass unnoticed.

In technical approach too there was a change, a complete change from "Spring Interior" with its loosely woven texture. "I wanted to eliminate the evidence of painting as such and to present the design with the least evidence of the means of accomplishment." Sheeler had never used elaborate under-painting or glazing. Now, he says, "while several months were required for the completion of this picture and similar lengths of time for those which followed it"—he was still painting only week-ends—"the time was not consumed by elaborate technical processes but in trying to maintain the statement with the least possible amount of revision. For I favor the picture which arrives at its destination without the evidence of a trying journey rather than the one which shows the marks of battle. An efficient army buries its dead." Concealment of the means of expression, which had always

been one of Sheeler's preoccupations, here reaches a new phase because of the scope of the picture and its considerable amount of detail. The philosophy of this procedure, or the instinct behind it, is clear: it meant that the subject could the more completely have its way.

As for the theme of "Upper Deck" this "involved no arbitrary rearrangement because of an esthetic impulse. These forms existed on their own terms, for use. Their disposition is utilitarian. Perhaps they could not readily be thought of as beautiful in themselves, but because they function there is a sense of truth about them."

The subject was in a broad way the industrial subject.

6

SHEELER may be said to have discovered, or uncovered, the industrial subject for American art, not only because of his early use of it, but because he gave the theme that clarity of revelation which made it subsequently usable, in a kind of crescendo, by others. Their handling has often diverged from his and has even presented a strong antithesis, assuming new contexts, becoming stormy, romantic, proletarian, or propagandist. This has been inevitable; but it was not inevitable to find the broad subject in the first instance or to strike through without preliminaries, as he did, to security in its use and to beauty in expression.

Behind a powerful innovation there is usually some sort of more or less submerged but concerted effort. A slow underground movement is likely to take place; a number of individuals, who may lack a final creative power, somehow contrive to edge into fresh fields, to send up trial balloons. But nothing of the sort seems to have occurred in relation to the industrial subject in this country, or if it occurred it was so obscurely as to escape notice. Something is undoubtedly revealed as to our typical attitudes toward the life we have created, by which we are surrounded, that this neglect existed for so long. With all that has been said about realism as an essential force in American

146

art and in the American mind our realism has been exceedingly slow to extend in this direction. In the eighteen-thirties the French scientist Le Sueur made a few sketches whose subjects might be called industrial—notably one of the head of an iron mine in Missouri—but these drawings only serve to indicate a prolonged absence of similar interest among ourselves. Even the conspicuous phase of industrialism which grew out of the Great War failed to bring about an acceptance of the industrial theme in our painting. We were late in entering the industrial revolution, and we have been slow to accept it as a respectable factor in modern life.

Thus Sheeler's uses of the industrial theme were the more original and significant. They meant a cleavage away from established attitudes, both social and esthetic. They might have been predicted from "Church Street El" or the several studies of New York office buildings or even from the telephone in "Self-Portrait." In all of these he had fully accepted the mechanical age on its own terms; but in 1929 the more direct alignment was still new. Superficially this might be related to the inclusion of small mechanical objects in the work of the French cubists or futurists, but these had been employed there in terms of fantasy. Sheeler has never used these materials or such arrangements; his interest in the industrial subject obviously sprang from a strongly rooted feeling for dynamic architectural forms. This is clear from the three crayon drawings, "Stacks," "Conveyors," and "Ballet Mécanique" (84). In each, immense intricacies of structure have been boldly reduced to essentials. The same preoccupation is more broadly stated in the two significant oils which preceded the group

of drawings, "American Landscape" (82) and "Classic Landscape" (83).

Hart Crane was later to say that the poetry of the machine age is no different from the poetry of other ages: and these paintings exist to prove it. Neither work is large, yet breadth is primary in both; like light it is an almost tangible element. We know upon consideration that nature was never quite like that, so luminous, so formally beautiful, so rich in design, yet nothing seems to have been altered to make them what they are. In a strict sense there are no backgrounds; every passage has been fluently co-ordinated with the others. Their planes recede and flow, achieve clarity and are quite simply translated into other planes: this is plastic form in a fresh and highly individual sense. It has often been said that Cézanne's planes in recession are not defined but closely interwoven. Here is an antithesis: planes in each painting are kept distinct, crystalline, defined by a characteristic use of exquisite line, and remaining peculiarly resilient. Of the two, "Classic Landscape" is the more abstract, but the same flow and recession appear throughout the closer detail of the other picture.

"American Landscape" contains an immense elaboration: note for example the doweled ends of the rungs in the ladder at the bottom of the picture to the right, and the tiny shadows which the rungs cast upon one side of the frame, and the subtle changes in line and tonal values within these forms by which the ladder is realized. Passage after small passage in this picture may be scrutinized for such yields, but these are invariably formalized in some measure; if the spectator lingers over them it will be by willful resolution. Until he comes to

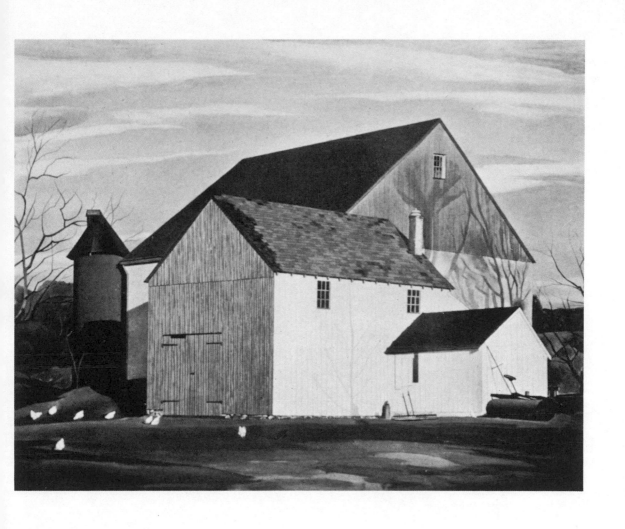

WHITE BARN

149

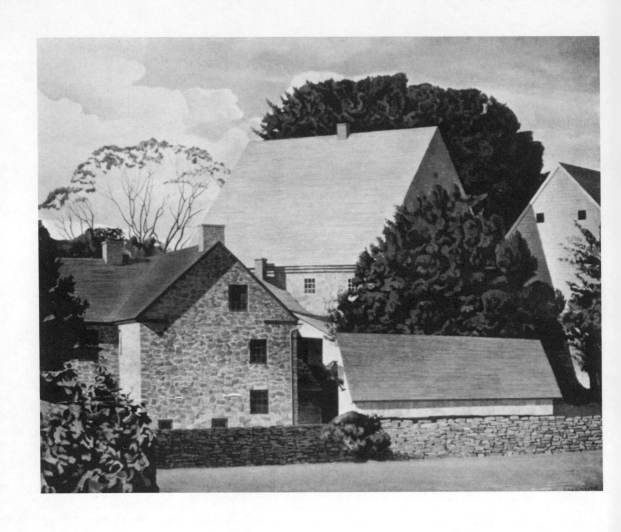

EPHRATA

150

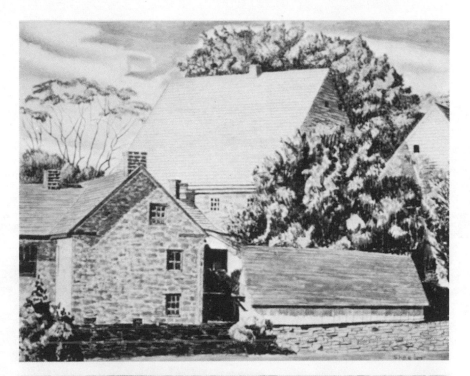

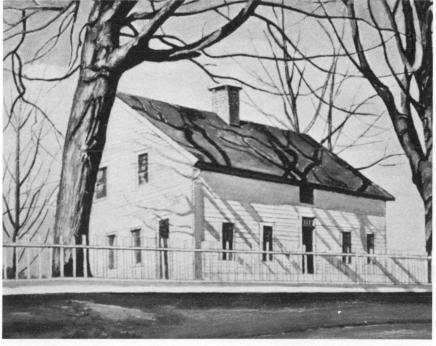

EPHRATA HOUSE AT NEWTOWN

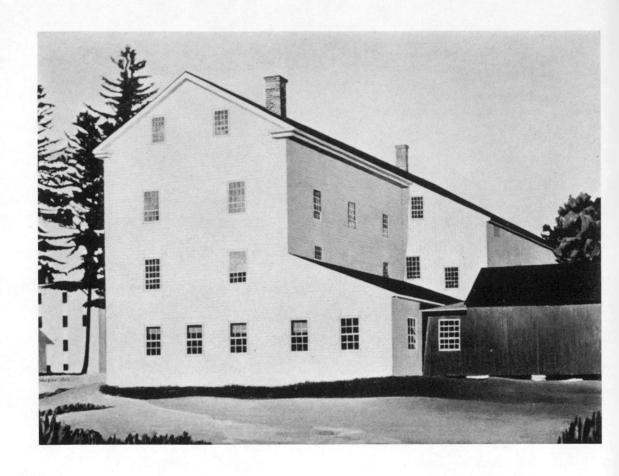

SHAKER BUILDINGS

152

know the painting well he will hardly find them at all, and even in his later consideration he may be involuntarily carried away into the broader scope.

For all their close representation, both paintings transcend realism. They have the elisions, the finality, and wholeness which belong to poetry, the concentrations which belong to figures of speech. Since "American Landscape" was painted its title has been applied by others with bitterness or disgust. Sheeler's use of the title carries irony but the world which he reveals produces no dismay. Nothing of grime or human waste appears there. He might say that these do not tell the whole story, that they may be ephemeral, that the enduring fact is that the vast mechanism has its own life, its own conquests and future. He has accepted industrialism and renders what he sees as its essential forms. These are pristine, as if the exhilaration of fresh certainties had gone into them, and they have the classic purity of form, the classic serenity. The title "Classic Landscape" wasn't chosen for the second picture, surely, to suggest that the painting itself is classic, but because the tracks, the standpipes, chimneys, the single building have outlines which may be compared with elements in Greek classic architecture. The designation might stand for either picture.

"River Rouge," an oil, somewhat deeper in color, makes a pendant for these two paintings, with closeness where they have space. If it possesses neither the finality nor the amplitude of the other two it is extraordinarily fluent in realization, as by the lighting of objects within the shed or the inclusion of the water-gauge, subdued in color and found late in the picture, a prosaic and simple form which creates

sudden involvements for the eye, affecting whole spaces and many forms within the picture. All three paintings employ somewhat the same range of color: grays, deep rust, cool yellows, white. In "River Rouge" there is less use of white, of the many whites, which make the others luminous.

Chronology nearly always has some sort of significance, and here it has a good deal to say not only as to Sheeler's command of his material but as to his basic intention as an artist. The logical progression, after his visit to the Ford plant, would have been a series of paintings and drawings which would delineate, in his own terms, this untouched subject. The obvious move would have been to exploit it. As a matter of fact, Sheeler did not use it at all in painting for two years after his visit to the Ford plant, and when he had painted the first of this sequence, "American Landscape," he turned at once to another group of themes, the interiors which have belonged conspicuously to his later work. The industrial pictures based on the Ford plant followed at intervals over a period of several years. He seems to have turned to them by way of alternation. The whole procedure indicates clearly enough the integrity of his choices, and that these did not have to do primarily with subject but with form. He was now engaged in a broad counterpoint among themes whose richness is shown by the striking variations among the four or five interiors which alternated with the pictures using the industrial theme.

"Home Sweet Home" (101) is cool, all grays, blues, blacks, with warmer tones and a considerable range of color within and beneath these, with a design of squared spirals that proceeds simply and delib-

erately through many progressions of form, none alike, none purely repetitive. It begins with the chair, it proceeds through squares or variations upon squares, and the journey is an interesting and varied one, through the wide broken circles made by the shadow of the chair and the stepped single-chain pattern of the hooked rug. Throughout are the tension and release as well as the finality of diametrical forms. If one goes beyond design—one need not—and wishes a reading in terms of underlying theme, the picture may be taken as a summary of generic character: it is essentially of New England not only in subject but in space and spareness, because of its singleness and its complication, a quality which is both quiet and uncompromising. Serenity is here, but with a fine, close edge.

Nothing could be more radically at a tangent in the use of similar materials than "Americana" (102). Local as they are, they are here unlocalized; this arrangement could appear as readily in a New York skyscraper apartment as in an old house in Connecticut: they are translated into pure modernism by the way they are placed, the way they are seen. Much warmer in color than "Home Sweet Home"—the yellow of the Shaker table, the stained dark red of the benches are dominating—"Americana" is also more abstract. Viewed from a height—a balcony—the wood of all these pieces is rendered in clear formal tones, not in grain or texture, and the patterns of the rugs are markedly flat and formal, but it is the dark benches which are responsible for the emphasis upon abstraction; the simplicity and form and scale of the table are heightened by their dark frame. Yet the folded paper, the Shaker box, the bread tray, the chair are acutely realized, as are the

155

forms at the farther wall, creating enough pause and involvement to clarify and stress the central theme, the table. The picture is all clarity, light, freshness, even humor as its lively variations are evolved.

The two interiors which followed—"View of New York" (103) and "Cactus" (104)—are both strikingly contemporary in their materials and wholly divergent in emotional impact. "I know that 'View of New York' may be called a cold picture, it is very uncompromising; some might call it inhuman. It is the most severe picture I ever painted." But its austerity is its beauty; it is cold as fresh moist air at a height is cold. Nothing could be more rigorously simple than its subjects: here are only a photographer's lamp, a covered camera, a camera stand, a modern chair partly seen, and the window. Cool grays with a slightly warm undertone and slaty, luminous blacks are dominating; the frame of the window shows a narrow band of vermilion, the stand on which the camera rests is deep red. The dissolving cloud forms in sunny white and warm gray could be taken as the major subject, or even light itself as it touches the frame of the window, the rim of the chair, and the wall; yet the rigorous window frame, the lamp, the camera stand have their own connotations, make their own clear upstanding pronouncements.

Height has been an inherent element in many or most of Sheeler's pictures, though without special accent, appearing in the slightly lifted suspension in space of "Bucks County Barn," in the tall stems of "Timothy" and "Chrysanthemums," in the theme of "Upper Deck." The view from a height is used in a number of paintings, as is the rising flight of stairs. Height in "View of New York" may be con-

sidered almost as a theme with a metaphysical content if one chooses: but that must remain for the individual spectator to define precisely; no picture offered less by way of obvious self-interpretation. It may be read, if one prefers, simply in terms of its subject as an extraordinarily handsome arrangement to which has been given a slightly ironical title.

Neither this nor the other interiors in this immediate group is still life. Though no figures are included, the suggestion of immediacy, of presences, is always plain from the placement of chairs or of smaller objects—in "View of New York" by the chair with its back to the light, and the open window, and the implication of use in the camera stand. In the same fashion though with a totally different effect in "Cactus"—an oil—the photographer's lamps have been focused and will be lighted; light already falls upon the subject from a lamp outside the picture. Yet none of these works is in any way a *genre* piece: each is formalized in essentials of handling, each has its special content, its own expressive values. Both "Cactus" and "Tulips" (127), a drawing made at about this time, seem an almost deliberate removal away from the high clarities and spaces of "View of New York." They have elegance, a modern elegance, in the glass of the table and the silky aluminum lining of the geometrically formed lamps. Stylization through the broad downward stripes of the backgrounds could only have occurred in an age when the machine had become a familiar instrument. In "Cactus" the gray green of the plant, the muted red of the pot, focus the few color tones in a picture designed pre-eminently by brilliant darks and brilliant light, and these prevail again in the drawing.

157

CHARLES SHEELER

Another broad turn occurred in Sheeler's use of the crayon draw-ing, whose close definitions seemed at this time to offer a particularly congenial medium. Like the paintings of this period, the drawings were completely realized as to environment, some of them with an almost incredible proliferation of detail. The delicate "Tulips" was followed by the extraordinarily life-like "Portrait" (126) with its close elucidation of character, its handsome blacks, its powerfully placed pattern. This drawing affirms Sheeler's gift in the field of por-traiture when he cares to use it, and is one of a number that have appeared at intervals, including an early lively and realistic self-por-trait in crayon, and an oil, "A Lady of the Sixties." They represent a substantial interest and are further evidence of the artist's refusal to be channeled by the themes for which he had become best known.

"View of Central Park" (125)—a crayon drawing—which belongs to these years, bears out the same assertion of freedom, with its rain-washed quality, its delicacy and scope, and another fresh departure in both handling and subject.

A characteristic move also occurred in "Feline Felicity" (128) which was drawn at a time when his use of the industrial theme had re-ceived widespread notice, when in fact a demand had appeared for "more industrial paintings." "Feline Felicity" went as far as possible in another direction, and is a deceptive picture. Its title almost goes out of its way to announce that this is a *genre* piece, a bit of naturalism, a sil-ver tabby in a ladderback chair; and those who wish may take it so: it seems all immediacy, all close detail, nothing is generalized. But shad-ows in nature do not fall in so beautifully soft and complex a pattern.

158

Light and shadow never played in any light with such perfect relationship against the silvery markings of the cat and the strongly rounded forms of the chair, within space. Though they do not seem so, these harmonies are outside nature. The subject has been floated quietly within a formal order.

The drawing belongs to a group of five which might be called a suite because of their alliances in theme, including "Interior with Stove" (137)—"The Open Door" (138)—"Interior, Bucks County Barn" (139) and "Of Domestic Utility" (140). Though the subject of "Feline Felicity" happened to belong to Connecticut it is linked in essentials to the others, which belong to Bucks County. Each has a homely, a provincial theme; each uses in one way or another those basic materials which have made a foundation for Sheeler's art. Their scale is large; they must rank with the paintings as major works. In craftsmanship they are extraordinarily flexible and close. The richness of their blacks indicates, as do those of the "Portrait," that Sheeler had achieved his youthful ambition as to the rendering of blacks: and he uses an equal tension in the many brilliances of light.

The two which seem the simplest, "Interior with Stove" and "The Open Door," are as accomplished as those in which the conquest of detail is startling and immediate: neither is truly simple. In the first it is hard to know whether light or the stove is the focusing theme: the two play against each other, with the forms of the window, the mantel, the beams, the door, securely defined, yet by almost impalpable means. Everything depends upon the position of the stove within the picture in relation to the apparently few, the actually many forms. No

159

one of them could be slightly shifted, diminished, or altered, but it is the triumph of this picture that nothing belonging to it seems arranged. As for "The Open Door," resolve it if you can. It has no component elements; it is an irreducible whole. As a study in light, in dimensional design, in sheer linear beauty, it is almost inexhaustible. It has been called one of the fine abstract pictures of our generation, yet it is as substantially realized as are the beams and tenons of the house of which it is a part.

In contrast, the detail of "Interior, Bucks County Barn" is prodigious, in subject, in textures, in minute expressive values, in exquisite gradations of light and dark: yet these are casually, naturally, set within recessive planes formed by the structure of the building. "Of Domestic Utility" may seem at first glance to represent another turn toward abstraction, and this judgment will be supported, one surmises, in the final estimate, but an acute and substantial realization is present in every phase of this drawing, in the blocks of wood and the porcelain of the pitcher and bowl. None of the group of drawings, one might almost say none of Sheeler's paintings, is more original in form than this, though the objects seem almost rudely placed. To follow its design is to enter upon a surprising experience as its dimensions widen, as its simple forms show fresh and unaccustomed relationships.

Again Sheeler was tending to work in cycles, but he broke these constantly by alternating themes. The drawings were not done in immediate sequence; indeed they could not have been done in this fashion because their minute workmanship meant great exactions and ocular strain. What strikes one is the broad orchestration in subject, feeling,

GOVERNOR'S PALACE, WILLIAMSBURG

161

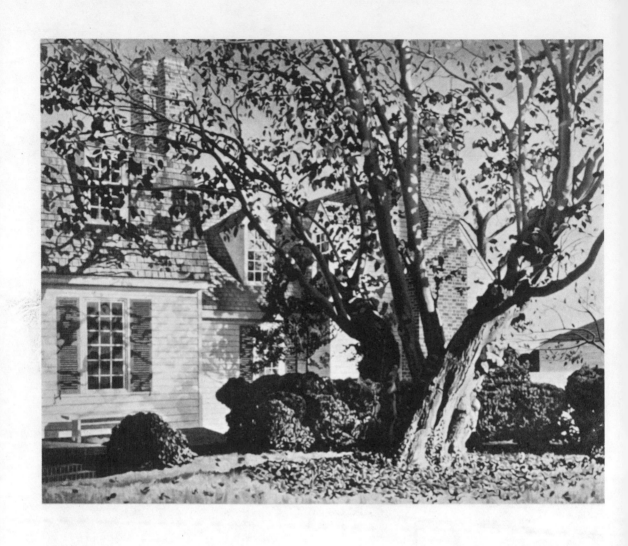

BASSETT HALL

162

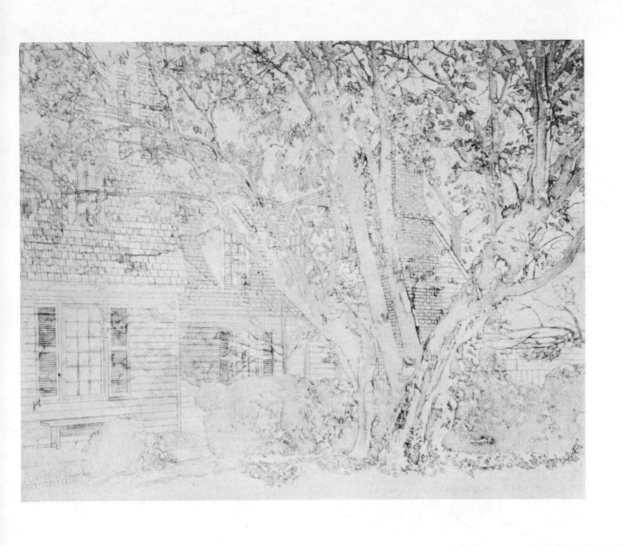

PHOTOGRAPH: DRAWING ON CANVAS, BASSETT HALL

163

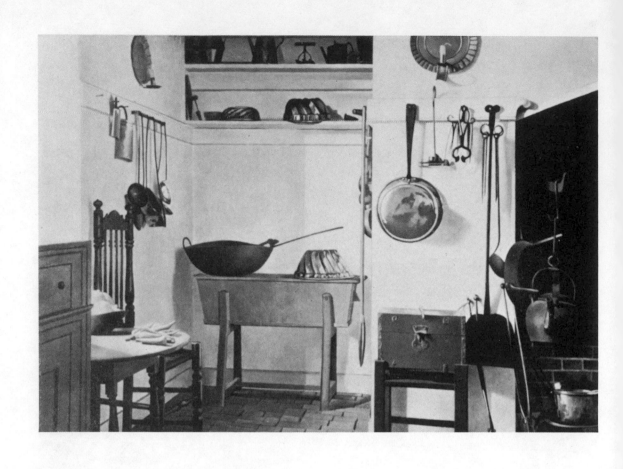

KITCHEN, WILLIAMSBURG

164

and form. The artist had rounded back again to the Bucks County subject and was to do so further within this latter period in "White Barn" (149), the general subject which in one phase or another had been basic in his work, here fully developed in one of the most serene of all his paintings, with its tranquil white buildings in the cool light of early spring, its interplay of brilliant greens, reds, and intermediate grays and violets with these whites, and the simple order of the whole. In the matter of design, he says, his preoccupation was the same as in the earlier work in tempera (61) in which environment was suppressed altogether. Here design is realized, unobtrusively, throughout an ample scene which seems fresh, pristine, untouched.

If the attraction of the communal subject for this artist needed proof this would appear in "Ephrata" (150), which has an early Pennsylvania theme though of a different architectural character from that of the barns: the cloisters and high-roofed meetinghouse, the boundary wall and ancient trees of that monastic community established by German Baptists in the early eighteenth century. These buildings are as rigorously simple as the barns, they have the same air of quietude and permanence, but the roots of this community went even farther back: medievalism appears in the high-pitched roofs. "Ephrata" meant the beginning of another fresh cycle of themes. This oil was followed after an interval by another, subtly altered "Ephrata" in tempera (151), one of a group of line paintings in miniature, which includes "House at Newtown" (151) and "Shaker Laundry." Crystalline in color, exquisitely developed with tempera or oil used almost as pure line is used, these are about four by five inches in size,

165

and represent one of the special departures of these years. The medievalism of Ephrata might have suggested them; they have much in common with the medieval art of illumination, yet the persistent absorptions of the artist are as clear here as in the major paintings. They are all architectural, it will be noticed, in both theme and in handling. A slightly larger line painting in tempera, "Shaker Buildings" (152), with the same finely, simply rendered structural forms, belongs in this group.

In speaking of "Upper Deck" Sheeler had said that this marked a turn away from abstraction toward design within fully realized forms: but he was far from letting abstraction go altogether. He was following no formula, the balance between the two elements was continually changing from one picture to the next, from one handling to another of similar themes. The clear differences in this respect between "American Landscape" and "Classic Landscape" are typical. They may be seen again if "Home Sweet Home" and "Americana" are compared, and the strongly linked crayon drawings show similar variations. Abstraction is always present in Sheeler's work to enhance design, and—one surmises—for sheer pleasure. It is not an accident that one of the most abstract of his early works has remained a favorite of his, "Stairway to Studio." While he says that he is "now through with abstraction as such" this may not be final; certainly one may expect its eliminating and synthesizing force to continue in his future work, just as his close sense of realization, stemming from so many sources, will also appear. Occasionally preferences or interests outside a special territory light up fundamental directions, such as the fervor with which this

166

artist regards Bach: "How he creates forms in space! He's never on the ground at all—never touches the ground!" He also entertains a strong admiration for Henri Fabre who in a way was all on the ground, all minute factual concern for what went on there.

It is his flexible use of these dual forces in art which proves Sheeler's cumulative mastery. His resolute refusal to be confined by subject matter offers a further proof. His range of conquest becomes apparent if the wide and changing variety of intrinsic design is scanned which he has employed since the painting of "Upper Deck," or even by the strong contrast between two such works as "Totems in Steel" (170) and "American Interior" (171), the one a powerful invasion of the upper air by mechanical forms, dwarfing the diminished human figure at their base, the other all richly textured intimacy. It is not simply that one is a drawing, the other an oil; the one stark, the other highly complex: the substantial use of form in each is in contrast. "American Interior" happens to contain a striking technical accomplishment in the rendering of thin, tangible glass, of plates whose glaze can be felt, whose complex patterns can be closely seen, in other patterns and textures: yet the final accomplishment, as in the far simpler "Totems in Steel," lies in formal values.

This is an art in which experiment has no place. Whatever was experimental occurred long before the given picture was begun on paper or canvas. Williams asked Sheeler how he arrived at subjects: "Do you go out for them, seize them?" "Not since we all trooped up to Gloucester to revel in the wobbly shadows. I can't go out and find something to paint. Something seen keeps recurring in memory with

an insistence increasingly vivid and with attributes added which escaped observation on first acquaintance. Gradually a mental image is built up which takes on a personal identity. The picture attains a mental existence that is complete, within the limits of my capabilities, before the actual work of putting it down begins. Since the value of the mental picture can be determined only by the degree of response it arouses in other persons it must be restated in physical terms —hence the painting."

None of these subjects was employed until a considerable saturation in their essential forms had taken place, through photography and study of the Ford plant, and by living with the Shaker pieces, with the modern tables, lamps, and so on of the later interiors. Robert Parker has said that "Sheeler's art is not a growth but an outgrowth. He works from a *milieu*, from an environment of which he gradually finds himself a part. Matisse, for example, used to paint anywhere, in a hotel room, in any temporary roosting place, but something would keep Sheeler from doing that. He is obliged to absorb his object— live with it, in the midst of it." Sheeler himself would probably say, "Let the subject absorb the artist."

The outcome is illustrated by the way in which "City Interior" (169) was evolved, one of the most complex of Sheeler's pictures, deriving from a study of the Ford plant, which was painted nearly ten years after his visit at River Rouge. No other work of his has so great an intricacy of detail; pattern after pattern is unfolded and interwoven within its larger dimensional design by the overhead conveyors, the tracks, the patterning of bricks of the walls, and the in-

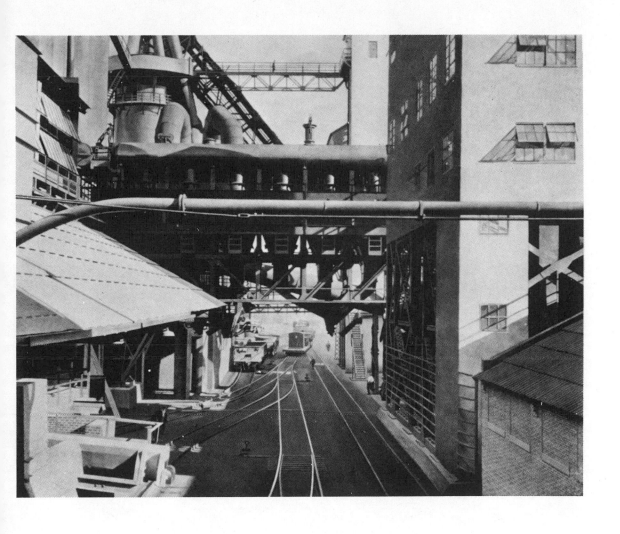

CITY INTERIOR

169

TOTEMS IN STEEL

170

AMERICAN INTERIOR

171

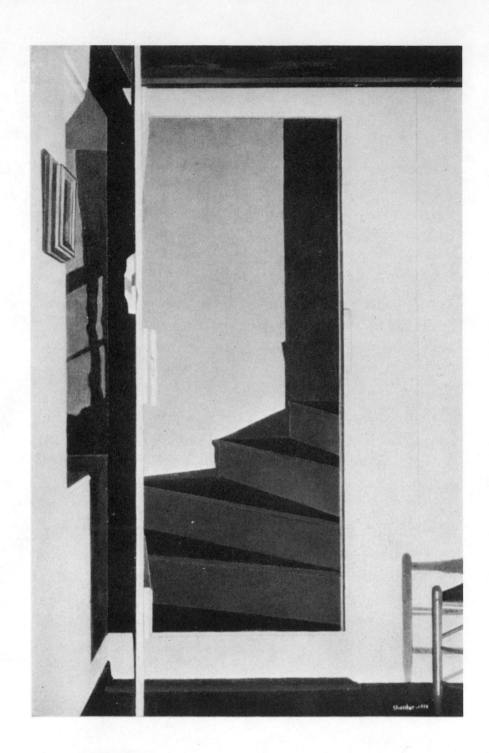

THE UPSTAIRS

172

tricate shadowing of ledges and pipes and roofs, and by the play of filtered light. The picture was planned after a considerable factual study, drawn upon the canvas, and was evolving area by close area, each in completion, when work was interrupted by another undertaking. The picture, approximately half finished, was left for eight months or more. When work on it was resumed, no revisions occurred; the painting moved to its completion without a break, apparently having sustained an independent existence during the time when it was untouched.

While this represents something of a feat and has its interest as an indication of the way in which a given artist works, it is more significant for its suggestion as to the way in which form may be appropriated, even the most intricate form, and become a possession. It is the classic approach, which means a full and instinctive conquest of materials before they are shaped. Each stage in this procedure has its own clarity, as is shown by the photograph of a very beautiful and typical drawing, on the canvas, that for "Bassett Hall" (163) in which every detail was rendered in delicately complete outline before color was applied. Unaccented as it seems, the use of line has imaginative force; though it was created for the service it could render to the final work, the drawing, which is now covered by the painting, made a wholly fresh expression of the subject.

Needless to say, an art of this order will not be prolific. Sheeler has never been an abundant painter, but his work has maintained a consistent freshness with a continually changing subject matter. The three paintings of the Williamsburg group—(161), (162), (164)—represent

a new but not an essentially different phase of the early American subject. The cool imperialism of the governor's palace is contained within comparatively small limits; this is a provincial palace though a handsome one. Neither this building nor Bassett Hall is unrelated as subject to the humbler architecture which this artist had hitherto considered. Each painting has its special character, even its varying craftsmanship, its special use of paint. The sheltered intimacy of "Bassett Hall" may be set against the dominant force of the "Palace." The "Kitchen" is all lively form, use, order, exemplary whites, and shining surfaces.

The "Palace" represents a wholly new departure in Sheeler's rendering of form. None of the accidental elements of light which seem almost to create solid form in "City Interior" is present here. Shadows are shown, as of the tree; and the retreating wall is shadowed, but though the form of the building and of the wall is built up brick by brick, detail by detail, in monumental solidity, none of the usual means of obtaining dimension are employed. Nothing is stressed: the building simply exists, with finality, with splendor and pride. Perhaps its full character could not have been revealed except in this absolute fashion.

7

"AM I A COLORIST? If you want to look at it in one way I am not. Values undoubtedly come first with me—those relationships of light and shadow by which form is achieved. Color wouldn't mean very much to me if it didn't have the structure of values to support it. I mean to use color to enhance form. It seems to me that we can't speak of a beautiful blue without reference to other blues, without reference to its relationship to other colors in the picture, or without reference to values.

"Is a colorist one who uses color for its own sake? I don't think so. Greco was a great colorist; and the color which he uses for his saints' garments is of no hue known to nature. This is also true of his flesh tones and even of his skies. All this is arbitrary, suggesting that he may have used color for its own sake, but though one thinks of it, color in Greco doesn't transcend other considerations. One thinks of form— some of the most beautiful use of form in the world. And there is no concern with surfaces in Greco—one doesn't think of them, only of expressive form.

"I can't separate the pleasure in color from other pleasures in a work of art, and the same holds true of the pleasure in the medium of which we sometimes hear a great deal, the liking for paint as paint. I enjoy the

use of paint—of course. But I can't separate this from an enjoyment of form. They all seem to me to belong together."

A new-found stress has appeared recently in the discussion of color and paint, and is exemplified in much current work, perhaps as a reaction against the pale tonalisms of impressionism or in conscious reaction against what is believed to be the Puritan tradition. "A *painty* quality. A juicy use of color." Yet this represents something which we have tended to repudiate in writing and in music. Rich tonalisms have less to say musically than they did before a-tonalism and the possibility of new structures came to occupy modern composers. Almost any journeyman reviewer will pounce upon the use of words mainly for their sensuous values in a book, and "a beautiful style" is a phrase which many writers would dread to have consistently applied to their work, as if the sensuous values of language had a super-existence of their own. Yet in painting the use of color in this sense still retains a fairly respectable place, both in practice and in critical comment—"the purple patch" in a medium where authentic purple may be used.

There are of course temperaments for which paint may be dominant though still as a medium, not an end in itself. Marin in speaking of Demuth's work has said, "How can a painter follow *line* or allow his paint to be controlled by it? The painter should follow *paint*." For Marin, a highly expressionistic artist, the guidance of paint is inevitable, like the pencil in the hand of the automatic writer. But surely line too may be a dominant concern, or form in space as with Sheeler. A more general assumption seems to be that sensuous values are dependent upon a special concern with color, but the absence of color may

also be sensuous. The pure whites, the simple forms of the paneling and doorways of New England farmhouses, often have unmistakable sensuous values because of the exquisite handling of surfaces and the modulations of tone which are accordingly produced. Such effects have nothing to do with elaboration, obvious color, or ornament. They may be created by geometrical drawings if the medium is expressively handled or—in literature—by abstract and scientific prose.

Sheeler's whites in his crayon drawings are as full of color values as is the diverse play of cool brilliant greens and reds and warm yellows in "Interior" (Whitney). Often his color is slightly arbitrary, as in "City Interior" (169), whose grays from light to deep tones, madder, ocher, and gray-blue are related to colors in the scene itself yet transcend these, being subtly altered for the harmonious elucidation of form. So unobtrusively has color been made to serve the larger end that the complex and very beautiful play of tones here as in others of Sheeler's pictures may easily be overlooked. He can use the colors in nature richly when he likes as in the recent tempera "Blue Ridge Mountains," where the receding blues are extraordinarily deep and tangibly fresh. Whatever his purposes, there are no trite juxtapositions; subtle as are its values, his color remains lucent, often transparent, and seemingly simple. In the recent "The Upstairs" (172), in which he has again gone back to a Doylestown theme with a great simplification of motifs, only the primary colors are used, red, blue, yellow in a high key, with brown in which the three are mingled, and white. The effect is that of a strong radiance, with the complications

177

of the window unaccountably balanced by the extreme simplicity of other forms in the picture, and with the varied tones of white in the narrow line of the open door creating a whole essential plane. In one way or another whites are developed in nearly all of Sheeler's work, many whites.

Craftsmanship appears in this so fluently that it is often hard to discover how one tone becomes another. In his extremely spare use of the oil medium, which he applies so thinly that it barely adds weight to the canvas, he often covers warm tones by cool ones or the other way about, but instead of the expected commingling or even conflict we have a simple and prismatic clarity. Craftsmanship appears also in the way in which paint itself is used. The result may not be "painty," quite the contrary, but the finished surfaces have their own esthetic values. Degas is said always to have run his fingers over any canvas brought to him by a young painter; if there were tiny lumps of paint or any break in the surface he had nothing to say. Sheeler has the same kind of feeling for surfaces, a feeling which as we have seen extends to all tactile values in his work; yet his canvases never have that completely finished smoothness which in itself attracts attention.

In the use of paint as in the perception of subject, a preternaturally acute physical vision has joined with an extremely supple skill of hand. Sheeler's vision has been called "monocular," but this would seem to refer rather to the singleness with which the subject is finally revealed than to the physical eye. Robert Parker applies the word "stereoscopic" to Sheeler's work, as if two or more images had been seen from minutely differing angles and had been superimposed one upon the

other to produce an intensive effect of dimension and sharpened detail, heightening one's close and immediate sense of reality. Parker believes that differences in physical vision among artists are greater than is generally supposed. "The usual assumption seems to be that they all see pretty much the same things but willfully render them in ways of their own. But surely in the past there have been great physical differences, as is shown by the 'Book of Hours' and other works of illumination for which a microscope is needed by most of us if their full character is to be seen. Probably painters now rarely see as much as that. We do not seem to develop the eye nowadays as an organ of exploration. It's almost as though Memling and some of the others possessed a different faculty. It is also interesting to consider how this operates as to the spectator or critic. Some of the finer qualities in Sheeler's use of color and his amazing rendering of values and tonal relationships may simply not be seen by many individuals because they haven't the eyes. And one can never be sure that all those who have them use them."

As to the basic theme to which this faculty has been devoted, there is no mistaking it. Sheeler is as passionately concerned with form as though form were religion. His work has sometimes been called religious, or approximate phrases have been used in the effort to define a radical and persistent quality. "Cleansing" is a sudden impromptu comment. "That teapot is fit for the Queen of Heaven"—in "Still Life" (73). "If as Henry Adams believed the dynamo has become a twentieth century Virgin then Sheeler is its Fra Angelico." His consciousness of the essential or generic is of course at the heart of his con-

tinued use of abstraction. Final and irreducible character in form is what concerns him. He is not, as a friendly critic has recently said, a pragmatist, concerned with things in the making, tested by whether they work or not. He is an absolutist, devoted to final values, a realist with the absolute view.

His primary intention is suggested by a comment on the question whether art is escape. "I don't agree with that idea at all. The artist isn't trying to run away from something. He's trying to run into something." What Sheeler has run into is never sheer fact in the literal sense of realism but something so much beyond fact that some of his most characteristic work may be called metaphysical, as the early "Bucks County Barn" and equally the recent painting, "The Upstairs."

In the matter of craftmanship Sheeler's bent was set early, as his early abstractions, or "Church Street El" alone, could prove. As to realism within the more recent phase of his work, he had taken his own direction before he went abroad in 1929, but undoubtedly his study of Hals and Greco and Velasquez during his student days abroad had much to do with his acute consciousness of both craftsmanship and the varied forms of realism, and this was heightened by his extensive study of the galleries during the later trip.

"In Velasquez and Hals the intensity of characterization is so vivid that though they are among the most brilliant of technicians their skill is never a barrier which prevents our entrance into their pictures. After the first impact it is interesting to the student to retrace his steps, enjoying an analysis of the means by which they arrived at these

results. With these artists the manner of application of paint on the canvas has a beauty of its own, and one may discern step by step the eventual consummation. But artists like Holbein and the Van Eycks conceal the means by which they set forth their statement. With them as with the others one receives a direct impact from the emotional content, but when one seeks to disintegrate their means of arrival the evidence just isn't there. Means and ends are fused together. Their pictures seem to have been breathed upon the canvases. There is no evidence of a beginning or ending. There is nothing whatever between the spectator and the picture.

"As for realism, one notices different approaches. In the Holbein 'Goldsmith' in the Berlin Museum things are accounted for to a degree of exactitude beyond belief. It is reality amplified through a stethoscope. The subject in nature, if we could see it, would seem only a feeble approximation of the picture. Holbein has distilled his subject. There are no adulterants of its basic reality. There is no way of translating adequately into words all the subtlety of the information which the eye receives in this picture, arousing our emotions. This provides an extension of our vision, revealing what without the eyes of Holbein might remain unobserved.

"The Rembrandt 'Beef' represents another profound approach to nature through realism. Here is a subject matter which might be considered base and unworthy, but which through the art of Rembrandt rises to a plane of emotional ecstasy no less than that aroused by a Pietà. The means used are entirely different from those used by Holbein, who makes his statement with the utmost precision, giving the same

degree of accounting for any of the accessories in the picture that is given to the characterization of the goldsmith.

"Rembrandt arrives at a presentation of a profound truth, not through highly specific detail but through generalities. Clews are given to the observer through the imagination. We are stimulated to contribute to the picture; and the clews are so rich, they lead us so far that in the end we have something the same thing as the detailed transcription. We see far more than we could have seen in nature, unaided. In both Holbein and Rembrandt the object is accounted for in all of its three hundred and sixty degrees of reality rather than the one hundred and eighty degrees which the physical eye usually takes in. Both have viewed their subjects with the physical eye plus the eye of the mind."

Sheeler's study of old masters has been primarily a study of craft, not of form or subject. His work may be related to marked phases of our earlier American painting, in his use of the cool palette, in the primary consciousness of design, yet he has never studied these consistently; they cannot be reckoned as an influence.

"The question of an American tradition in painting could worry me quite a bit if I would let it. Obviously we are a composite of many influences, but the same thing is true to an extent even of French art. Consider our friend Picasso from across the Spanish border. We seem to derive from many sources. I suppose some variation from these sources makes something which is our own, but just how to define this!

"There are early American works which I have enjoyed—the por-

traits of the Van Alen sisters, for instance, by Pieter Vanderlyn. One hardly knows which to prefer, both are so fine. Both are organized with great distinction and dignity. The painting of the hands is *naive* but the very beautiful line around the mask of the face is not *naive* at all, and suggests Velasquez, who often painted a face quite flat in the same way with a line around the mask, as in the portrait of the poet and in some of the portraits of the Infanta. Color is reduced in these Vanderlyn portraits to a minimum—all is fine organization, characterization, and really fine painting. And there is the work of Raphael Peale, about whom nobody seems to know very much except that he belonged to the well-known family of painters. A few of his still lifes have been found, and then this one picture which might be called a still life—one could place it among the Chardins. It is really a portrait of a white sheet, hung up to conceal a nude girl whose head and feet are visible. While the subject is really the sheet this is so packed with visual interest that one never remembers how commonplace it is. There are great variations in form within its boundaries, elaborated by the creases and curvatures in the surface. The color consists of gradations of white, cool white, with the highest light inclined to be bluish. It's the finest nude I ever saw!

"Our folk art shows us something of the character of the people of the time in which it was produced, and it often has characteristics common to the most satisfying expressions of any period: simplicity of vision and directness of statement with a considerable sensitiveness and originality in the use of the medium. This art is *naive* and carried conviction at the time, but I feel that the *naive* may not be reverted

to now with similar conviction. Sometimes one sees an effort in that direction, but we live in an age that is already highly sophisticated and there is every evidence of a farther advance in that direction. I feel that the language of the arts should be in keeping with the spirit of the age and that we should be as knowing as our capabilities permit.

"As for certain American painters of the past who are ranked as outstanding, I find myself at variance with this opinion—as to Winslow Homer, for example. These are ideas which I have had to formulate in relation to my own work. They are purely personal opinions— working opinions, not intended to replace those which others may have.

"Unlike Holbein, Homer confines his accounting for the subject to one hundred eighty degrees of physical vision. The objects seen in space do not have this final totality of existence which Holbein or Rembrandt achieved but are viewed solely from the front. Our point of observation is fixed; we are not permitted to look around corners. Homer often uses generalization of forms, but that generalization, in contrast to Rembrandt's, does not lead us to extensions or explorations; rather it is like the room between closed doors beyond which we may not go. In the sea pieces, waves rise to a crest with the assistance of the artist but they will have to find their way unaided if they return to the level from which they arose. This is, I feel, the realism of the stage-drop, and it often incorporates the actors and is illustrational.

"Eakins has informed us by his pictures of his invariable preference for the homely subject—men and women of unarresting personalities.

For the most part these subjects in themselves provoke as little interest as that of Rembrandt's 'Beef' but there is a vast difference in approach. Eakins tells us that he found his subjects like that, and he delineates them on their own terms. Rembrandt tells us that though we may think his subject unworthy, he will prove that all subject matter is but a springboard from which to project the statement of the artist. Unlike Eakins, Rembrandt imposes his own terms upon nature. Eakins had a sense of craft but it was mainly clinical. Somewhere there was an emotional element but he seldom got around to reveal it. He never lets us share the sense of beauty which he may have seen in these homely characters. The great realist offers a final enhancement—a plus. We get his vision of the facts as well as the facts.

"I feel the same way about our early Bingham, who had almost everything: but he didn't use it. He leaves nature where he finds it without that plus which represents what the great artist sees. He was highly articulate, and he had an unusual subject matter with all those frontier scenes but he thought it was enough merely to record them. He didn't read between the lines. He didn't show us what we can't see for ourselves. He made no disclosures. He had plenty of words, quite an amazing technique and great fluency. Perhaps if Cézanne had been as articulate as Bingham he would have been a still greater artist. But no—I think this is a way of getting at what I am trying to say about Bingham. He found his words in Webster—that is, in a common source and the result is essentially commonplace—while Cézanne made his dictionary to suit his needs. Bingham is a good example of the fact that a vocabulary in art is not an end in itself.

185

CHARLES SHEELER

"As for Ryder, his subject matter almost invariably had its origin in an idea contained in a specific poem or in an image evoked by a poetic idea. A given picture was, as we know, built up over a period of numerous years with many additions and subtractions in the course of the elusive process of transforming the image of the mind into an image for the eye. Nature was a point of departure for his flight into fantasy. Fantasy has its place in art, but I feel that in Ryder this was never fully translated into the special terms of painting. His uncertainties, his continual revisions are partial proof. I suppose no artist known to history ever revised his work so often. He had no sense of the painter's materials but built up his canvases with layers of varnish and bitumen. He never seemed to care about his craft enough to learn it. It seems to me that there is very little in Ryder that we cannot learn in literature, and not so well, because we are continually being troubled by his struggle with his medium. I can't think of his being a strong factor in the world of painting as are the major European artists.

"Eakins, Ryder, and Homer simply don't give me that final sense which I feel in great painting—like radium, extracted from a mass of pitchblende."

The influences by which Sheeler has been affected in terms of painting seem to have come not from American art of the past, but from Europe, from the older masters, from French modernism. Throughout all his work he has rejected nothing which could further his purposes whether from France or Holland or the west coast of Africa. This circumstance may serve to lay a specter which has

186

haunted and still haunts a good many artists and critics. We have been obsessed by the idea that so many tides of influence from the outside have washed over us that we can never have an art of our own. Sheeler's art is proof to the contrary: beyond its derivations from native sources it achieves a composite of qualities which could belong only to ourselves. It is affirmative, not with the lush exuberance which we have frequently expressed but in the other fashion which equally belongs to us, that of understatement. Its economy is of an order most frequently associated with New England, but it has inhered in our western speech as well, in some of the broadest humor of our frontiers. Quirks of humor are glimpsed in such titles as "View of New York" and "Self-Portrait," and these appear in Sheeler's art along with that sense of order, function, and design, which with all our sprawling breadth we never seem to have lost, and which has often linked itself with our feeling for science or mechanics. For this reason his use of the camera means a wholly natural alliance. The buoyancy of his art, its employment of light as a palpable element, its clarity of form have belonged to much that is characteristically ours; nor is its underlying subjectivism a purely individual inclusion.

This is difficult to prove or define; Steichen has spoken of the subjective element in Sheeler's painting as compared with his photography. Its presence in such paintings as "Church Street El," "Stairway to Studio," "American Interior," could be warmly contended for. It appears perhaps most clearly in a mingled tranquillity and intensity which can only have come about because the subject has been transformed by an inner apprehension. "Art is self-inventory, that's all

187

there is to it," Sheeler says: and this seems to indicate a process which he follows. To what extent subjective forces have belonged to our painting in the past we shall know better when its history is more fully understood, but even now it is plain that they have appeared in many a small anonymous watercolor or drawing as well as in much of our folk art. When the full story is told they may perhaps be seen to have played a larger part than now seems likely. Certainly the subjective has belonged to our tradition in literature—consider Poe, Hawthorne, Henry James. It clearly belongs to the modernist movement, of which Sheeler is a part, noticeably in French painting. Whether it has been strengthened in his work by French influence is immaterial: it continues a language which is essentially our own.

His art has mistakenly been called impersonal because its emotional values are reticent enough to be missed by those looking for the bolder, more assertive forms of self-expression. His individualism still has no shade of bravura. It is never difficult to single out a Sheeler in an exhibition, yet characteristically this artist says that he aspires to paint pictures which will not be recognized as his. What he has said in regard to his use of color is suggestive for all his work. Nothing is important for its own sake, each has its place only for what it says in relation to the subject. "I can't separate." Singleness of this order is the essence of the classic approach. This is not to insist that each painting is wholly classic in feeling; there are variations in stress or achievement just as there will be variations in individual approval or choice. But the major intention of Sheeler's work has remained within the classic intention, even in his later phase of a complex realism,

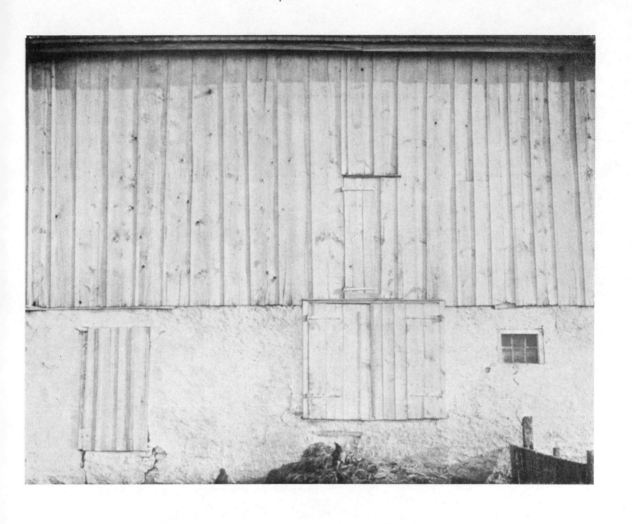

PHOTOGRAPH: SIDE OF A WHITE BARN

189

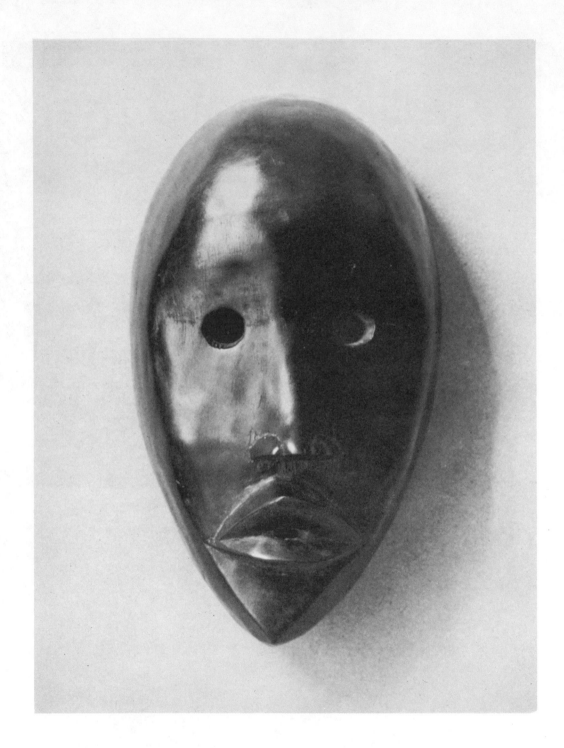

PHOTOGRAPH: NEGRO MASK

190

PHOTOGRAPH: CHARTRES

191

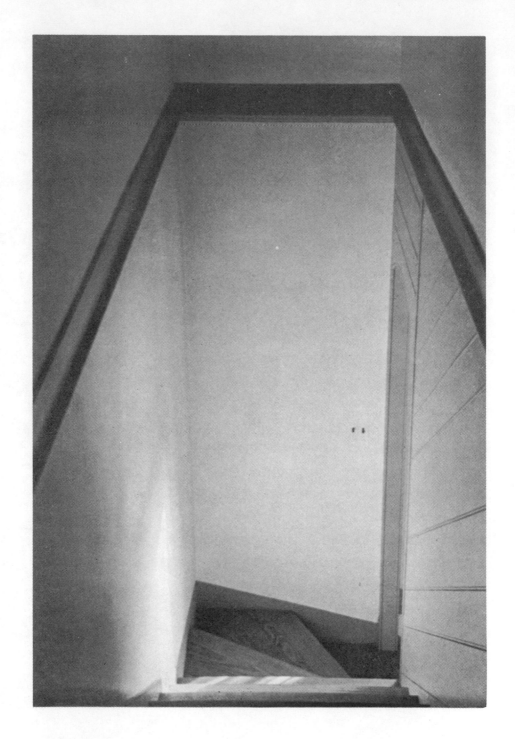

PHOTOGRAPH: STAIRWELL

192

even in so intricately organized a picture as "City Interior." His art suggests a recovery of the simple and unstressed classic mode, which has truly belonged to us and which, broadly, may belong to us again.

Individual as his art is the subjects which he has chosen and the influences to which he has submitted have, almost without exception, represented an outflowering of social usage or tradition: Bucks County architecture, the communal architecture at Ephrata, Shaker architecture and crafts, and, outside our own range, primitive Negro sculpture and Chartres. There is no accounting for this primary direction; it has been a matter of instinct and temperament. It has been as manifest in the larger sequences of his photography as in his painting. It is repeated in his choice of the industrial subject. Our spare, highly mechanized industrial plants have been spoken of as though they had sprung full blown into existence within our time, but the shedding of extraneous details in their forms has been a gradual process, coming slowly toward completion as simplified structure has become a necessity with the rise of mass production. This has tended toward elementals, as in the best of our frontier buildings of the humbler order, and for the same reasons, those of economy and adaptation to use.

Sheeler would be the first to acknowledge what he has gained from these expressive materials, not only by way of subject but influence. "No one can achieve a detached identity. Those who insist that they maintain their own Delco systems really mean that they don't believe in credit lines." It is undoubtedly true that he has never wished to establish anything by way of general principles by

193

his art; as at the time when he first chose his vocation, he has only wished to paint. Yet through his choices of materials and his use of them, certain highly productive ideas become clear. He is as much at home among the forms which promise our future as among those which have been essential in our past. It may be argued that the machine age has made so deep a cleavage in our social and esthetic experience that the forms of the older world have nothing to offer to the creative forces of the present day. Sheeler's work proves the contrary. To scan it is to find many alliances between the past and the present, as between the Shaker crafts and modern functional forms, as between buildings of both eras. The basic subject of his "Shaker Buildings" or "Shaker Laundry" may be compared with the single structure, say, in "Classic Landscape." Obviously the alliance is accidental; one could not have derived from the other, yet the forms, the ratios of proportions seem to have come from a single source.

Such interconnections are further suggested by Sheeler's photographs of the Ford plant, notably one of a great room in the steel mill, which has the clear, the airy severities that dominate the simpler forms of our early provincial architecture. These alliances have great suggestive force; they open up whole creative areas by which the sense of our traditions may be more richly defined. Sheeler has come upon them by the best of all testimony, that of the perceptive eye. Indeed it is only through the eye, not by means of theory, that they may be genuinely confirmed. They are important because they indicate that our esthetic lineage, instead of being impoverished

as we have often been inclined to think, has many lines of great strength and diversity.

Sheeler's search for form in American sources would be enough to give his work a unique position even if there were nothing more to say of it. His discoveries and his use of them may have a signal importance for the future. There can be no doubt about the vitality of the current movement in art, among the younger generation, nor of its tendency to move more freely by its own power than seemed possible twenty years ago. Young American artists find it infinitely less difficult to reach an audience and are more detached from foreign influences. But though they may be emancipated in part at least from the still powerful French movement in modern art, they sometimes seem to bend themselves too anxiously to a search for themes; they often apparently feel that form is something which may be picked up according to taste or interest from almost any source. They say, "The Michael Angelo 'Last Judgment'—there's something!"— as indeed is true. "That multiplication of images—the same thing may be found in a mob in Union Square!" Or they find a special magic in the Rubens "Return from Labor in the Fields." "All modern art has somehow gone back to Rubens." Yet it might take a lifetime to fathom the basic form which makes these paintings great works of art, and then the hard-won possession might not be translatable even humbly. It might sit askew upon Union Square or the Berkshires. As we have seen from the origins of our provincial buildings, form in any deep meaning of the word is the result of a great number of experiences both social and individual. It is a matter of slow growth,

and is the final touchstone, both for the individual and within main movements. It cannot be easily borrowed, and has most validity when it springs from natural and full, native affiliations.

All of this generation is under a great handicap in the matter of form in the plastic sense, not only because our traditions have seemed to be broken or discontinuous, but because a mechanized age has removed the handicrafts with their schooling of the sense of touch from our experience. Almost no one grows up with that extremely subtle tactile sense which was once fairly common. Unless the plastic arts are to go out altogether, this is a loss for which some sort of compensation must be found.

In his derivations from plastic forms, as well as in his discoveries, Sheeler has opened up an essential compendium for the modern artist. He has chosen what has best suited his own needs, and it happens that he came from a part of the country where such sources are particularly rich, eastern Pennsylvania: but they have developed and may be found in many other places. We have often thought of them as belonging to the older, more settled areas but we are beginning to learn that they were often richly developed on our frontiers, our many frontiers. Not all of them were classic, far from it; often they are full of the most innocent romanticism. Part of our unconcern about them has come about because we have swerved so widely from our avowed principles, in esthetic matters as elsewhere. Luxury of one kind or another has widely engaged us. These are essentially democratic arts. They provide an anatomy of our creative powers during the periods when we were becoming what we now are, and they could

be used for art as the human anatomy is used, as subjects for study, even for thoughtful dissection, to discover their plastic secrets. A sound homely furniture, iron and wooden tools, pottery and the glass created by itinerant glass-blowers continued to be made in many places long after the machine had triumphed. Their forms are deeply embedded in our social experience. Nor are they truly inanimate. They are rich in human expressive values which may be appropriated the more fully as we learn more of the life out of which they sprang. They need not be used as subject matter for art. Their final translations might be into renderings of landscape or of the human figure.

Such recent works as Sheeler's tempera "Blue Ridge Mountains" or the crayon "Cliff at Steichen's" contain such implications as fully as those of his paintings in which he has used these materials as motifs. The cliff is monumental, but no attempt has been made to dramatize its force by projection against space. The drawing offers only the sun-drenched flight in stone with its intricate and beautiful fissures and layers and clefts, but Sheeler's basically simple sense of form is there, within a theme which might seem to offer only a complex natural form, in an exquisite yet powerful delineation.

His future work is hardly predictable; as in the past he may make new transitions, by instinct rather than logic. He might use further subjects drawn from nature. He has occasionally moved outside the American theme in what he calls irrelevant associations, as in an early still life which combined an Etruscan vase with a French gravy-boat and an American apple, and he may do so again in fresh connections. "I like irrelevancies and think of them more often than I set them

197

down. I might even explore fantasy, in spite of what I said about Ryder, but I believe I should prefer it on the less serious side.

"In the 'White Barn' there is something to which I gave some thought when I painted it, building up a sense of permanence by using contrast between elements which were mobile and static. The chickens might change their places, the barn wouldn't—that was the idea. Well, these things might fool us. The barn might change and the chickens wouldn't. One might do something with ideas like that in painting." Sheeler's liking for the fantasies of Pierre Roy suggests a further phase of the same temperament, though it is by no means certain that he will give such ideas anything more than verbal form. Whatever he does, it seems reasonably clear that he will not become a propagandist of any sort, not even for the study of American sources.

His art has differed, often measurably, from that of his contemporaries in subject, form, and craftsmanship. It may not be in one or another of the immediate streams but it is in our main stream. Though its revelations as to American traditions in art are particularly wide, and though these must be stressed since no one else has made them, Sheeler's work remains securely placed outside these considerations. Significantly, many of those viewing it for the first time do not mention its subject matter, but try to phrase the impact which they feel in terms of emotion. There is justice in the circumstance that he is now seldom mentioned as a painter of the American scene though he has produced genuine discoveries in this direction. Rightly, his work has come to be judged in terms that are less transi-

tory. It speaks with a singular directness, as if nothing were interposed between the artist and his theme. Even those paintings and drawings which may be called metaphysical have this high clarity, like light itself, or a medium which this artist alone has created. Whatever may be said of Sheeler's discoveries or his innovations, the works themselves remain first and final, and are timeless, with their rendering of absolutes, their buoyancy, serenity, and strength.

INDEX

INDEX

INDEX